SECRET EYAM: PLAGUE VILLAGE

Jill Armitage

AMBERLEY

First published 2023

Amberley Publishing
The Hill, Stroud
Gloucestershire, GL5 4EP

www.amberley-books.com

Copyright © Jill Armitage, 2023

The right of Jill Armitage to be identified as the
Author of this work has been asserted in accordance
with the Copyrights, Designs and Patents Act 1988.

ISBN 978 1 3981 0920 9 (print)
ISBN 978 1 3981 0921 6 (ebook)

British Library Cataloguing in Publication Data.
A catalogue record for this book is available from the
British Library.

Origination by Amberley Publishing.
Printed in Great Britain.

Contents

Introduction

Eyam.

Eyam (pronounced Eem), given the Saxon name 'Eaham', meaning a well-watered hamlet, is a secluded Peak District village hemmed in by green slopes and majestic hills. Within ¼ mile, the busy world passes by along the A623, yet every year thousands of people head directly to this isolated rural community, tragically famous as the plague village that self-isolated.

The year 1665 saw outbreaks of bubonic plague in London and many other cities, towns and villages across England. The incomprehensible terror of the plague, caused by the bite of a rat flea infected by the bacterium Pasteurella pestis, arrived in Eyam in September 1665 and in order to contain the disease, the villagers chose to lock themselves in isolation. This was an act of true altruism by grief-stricken people in a village where every home became a morgue and every resident a mourner.

Ring a ring of roses, a pocket full of posies. Atishoo, atishoo, we all fall down.

This seemingly innocent children's nursery rhyme is in remembrance of this 1665 plague. The ring of roses refers to the body rash; the pocket full of posies were the herbs carried in an attempt to ward off the disease; and the sneezing was a symptom of the plague, which would lead to falling down – dead. After a very long fifteen months it was all over, but 260 residents of Eyam were dead.

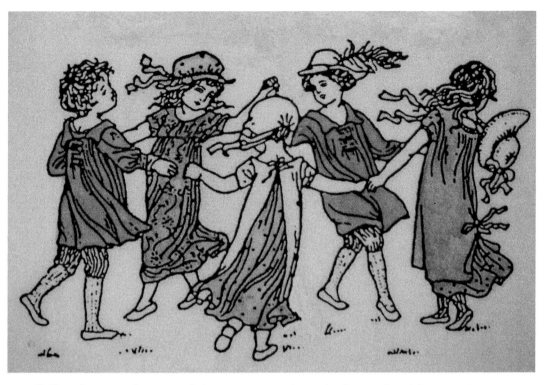

Children dancing to the seemingly innocent nursery rhyme that has a rather sinister meaning.

Over 350 years later, as we have encountered a pandemic of gigantic proportions with Covid-19, the story of Eyam has inspired Simon Armitage, Poet Laureate, to devote half of his poem *Lockdown* to the suffering of these people:

And I couldn't escape the waking dream of infected fleas in the warp and weft of soggy cloth by the tailor's hearth in ye olde Eyam.
Then couldn't un-see the Boundary Stone, that cock-eyed dice with its six dark holes, thimbles brimming with vinegar wine purging the plagued coins.
Which brought to mind the sorry story of Emmott Syddall and Rowland Torre, star-crossed lovers on either side of the quarantine line whose wordless courtship spanned the river till she came no longer.

Secret Eyam: Plague Village weaves these snippets into the area's history, uncovering curious facts and undisclosed stories. It's a book for enjoyment and recreation complied at a time when we are again in the grips of a global pandemic.

1. Eyam's Early History

Eyam is a secluded Peak District village surrounded by green slopes and impressive hills. Customarily called the White Peak, this is an area divided into a patchwork of fields by dry stone walls that glow white in the sunlight, in comparison to the darker, flatter rocks in the gritstone areas. Yet ironically, it's the gritstone edge above the village that gives Eyam its name. In the Saxon tongue, 'Eaham' means a well-watered hamlet – 'Ey' is a Saxon word for water, and 'Ham' means a settlement – yet there is no river running through this peaceful village. The gritstone moorland above the village allows rainwater to filter through the strata into limestone and reappear further down the hillside as a series of springs where the underlying impervious shale is exposed. Church Street, Eyam's main road, follows the junction between gritstone, shale and limestone, thus giving the village a plentiful supply of spring water – and its name.

Eyam has a long history that stretches back before the previously mentioned Saxon period, but ancient history seems to centre around the gritstone moor. Now known

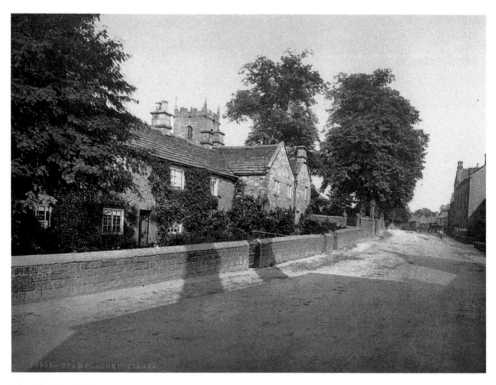

Church Street, Eyam.

as Eyam Moor, it rises to 1,418 ft above sea level and is crowned by Sir William Hill, a one-time packhorse route and salt road linking Sheffield with Buxton and Manchester.

Did You Know
The whole of Eyam Moor has considerable evidence of primitive man's passing. It is rich in chambered tombs, stone circles and burial mounds, the littered reminders of our Bronze Age ancestors.

During the Bronze Age, this area would have been covered with rich farmland and woodland, not the dry peat moors of today. Farming communities would have been dotted around the area and intermingled with the round houses would have been the primeval burial mounds now recognisable as low hummocks in the heather. Until archaeology became a recognised necessity, little importance was paid to these mounds. There was little scholarly interest in pre-Roman history in England before the eighteenth century, dismissed by historians as a dark and shadowy period. Over the centuries, most of the lumps and bumps have been destroyed by farmers and wall builders while others had been opened for curiosity or treasure and been badly plundered.

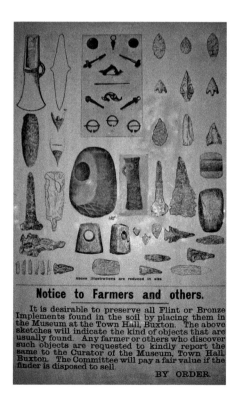

Above illustrations are reduced in size

Notice to Farmers and others.

It is desirable to preserve all Flint or Bronze Implements found in the soil by placing them in the Museum at the Town Hall, Buxton. The above sketches will indicate the kind of objects that are usually found. Any farmer or others who discover such objects are requested to kindly report the same to the Curator of the Museum, Town Hall, Buxton. The Committee will pay a fair value if the finder is disposed to sell.

BY ORDER.

Farmers were encouraged to report prehistoric finds.

Records are scant but the few that do exist tell a sorry tale. For example, at the site of a large tumulus on land called Hawley's Piece, an urn of great size and antiquity was discovered near the centre, and the finder took it home with him. When the superstitious finder lost a young cow and began to experience a period of bad luck, he decided that the precious relic was unlucky and buried it – site now unknown.

Records of similar finds dismiss them as nothing more than a few personal objects and cinerary urns containing bones and the ashes of the long dead. With the chance encounter and primitive means of attempting to remove these urns, it's understandable that most fell to pieces.

It was while Occupation Road was being built around 1790 to provide employment/occupation during a period of industrial recession (thus the name) that an ancient, richly decorated cinerary urn was found by Mr S. Furness of Eyam. Details of a similar cinerary urn found in 1912 near the verge of St William Hill are in the 1912 edition of the *Derbyshire Archaeological Journal* (Vol. 34, O'Ferrel, pp 51-54). The Derbyshire Archaeological Journal was founded in 1878.

There's further evidence that this area was inhabited by prehistoric man when more cinerary urns were found on the border of Eyam and Bretton. They are now in Western Park Museum, Sheffield. Pioneering archaeologists Hayman Rooke and Samuel Pegge combined field research with documentation, plans and drawings of their findings. Pegge's 1784 woodcuts of urns and grave goods are some of the first published illustrations of pre-Roman pottery in England.

On what is called Smith's Piece, there is an enormous gritstone rock containing a rock basin marked on ordnance survey maps – 218.783 Whether it was hollowed out by the natural action of rainwater or the work of man is unknown, but it was allegedly a place of pilgrimage where thousands of years ago people placed votive offerings. It could also have acted as a trading place during the 1664/5 plague, the basin holding water or vinegar to clean the coins.

Early archaeologists.

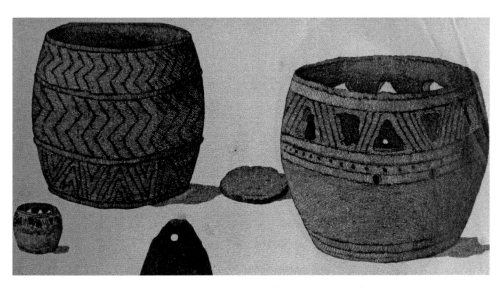
Woodcuts of the first pre-Roman pottery found in England, identical to the Eyam finds.

The boundary stone between Eyam and Stoney Middleton is best known as a trading place during the plague. This stone that Simon Armitage refers to as 'that cock-eyed dice with its six dark holes' is a survivor from prehistory and is a purely regional phenomenon occurring in northern Derbyshire, West Yorkshire, Northumberland and parts of Scotland. Known as 'cup and ring stones', circular carvings are cut into the surface of usually earth-fast rocks and boulders. There are regional differences in the designs, and in Derbyshire, the style is often for groups of cups of different sizes clustered together. Their purpose is unknown but may have delineated boundaries, the location of springs, or sacred places.

Did You Know
The original purpose of cup and ring stones is unknown, but one gained notoriety as a boundary stone between Eyam and Stoney Middleton when during the plague year, the cups were used to hold vinegar believed to disinfect the coins. A series of Derbyshire stones with the cup and ring markings are now in Sheffield Museum.

Did You Know
A survey carried out many years ago identified some thirty-five stone henges in Derbyshire dating back to the period 2,500 –1,000 BC. Eyam has its own Stone Henge known as Wet Withens. Dubbed one of the country's least visited prehistoric sites, this is where Druid priests would undertake religious ceremonies and sacrifices.

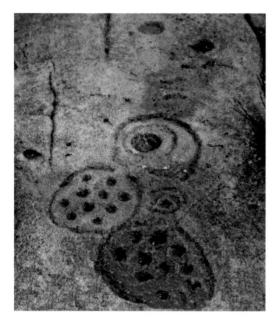

An example of a cup and ring stone.

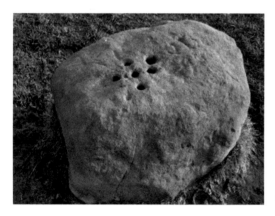

The boundary stone.

Almost in the centre of Eyam Moor is a large embanked stone circle known as Wet Withens. Out in the open moor, it is hard to locate, but it is marked on ordnance survey maps at 226.790. Wet Withens now consists of ten obvious standing stones set in a bank of approximately 30 m diameter. Most of the stones lean at quite an angle, but when upright, all would have been under 1 metre tall. A drawing from the 1800s shows sixteen stones. In the 1842 book *The History and Antiquities of Eyam*, William Wood refers to this as an ortholitic circle, a stone circle of around 100 ft in diameter with twelve to sixteen standing stones. Popular tradition states that it would have been the centre of Druid ritual and ceremony. For many hundreds of years, people would have travelled here from miles around to worship their gods and ask for help with the harvest or to ensure the continued fertility of the land and community.

Stone circles are thought to have been special places where chieftains and important people were buried in the belief that the power contained within its stones would transport their souls to the afterlife

It is still believed that these stones have special powers. They can help healing, aid conception, and hold electrical energy. Some people who touch the stones are able to feel the energy and people who are particularly sensitive to changes in atmospheric pressure have reported hearing faint sounds like whining, humming or buzzing, much like those emitted from transformers and power lines, coming from the stones. There is certainly an atmosphere about such quiet, isolated places that owe much to their long-forgotten past. As with the cup and ring stones of the same era, all we can do is surmise and theorise as to their meaning and marvel that they still survive in the Derbyshire landscape.

Eyam, Centre of the Roman Lead Mining Industry

Two thousand years ago, the Romans would have tramped across this moor with packhorses carrying the area's most precious commodity – lead. A conical block of lead was found on Eyam Moor many years ago. It was probably jolted off a wagon or packhorse carrying pigs of lead or ingots. It weighed 30 lb and had a hook or handle attached, probably to disengage it from the mould or to facilitate its easier handling. Lead was certainly mined in Derbyshire before the arrival of the Romans in the first century and was a valuable commodity which prompted them to stay. Roman coins, a lead spindle whorl and a perforated stone adze were found in a former allotment site in the heart of Eyam when a small housing development, now New Close, was built there in the 1940s.

The Romans were certainly interested in the lead that was mined in this area and sent huge consignments back to Rome. As well as extending natural caverns, the early lead miners worked the 'rakes' or surface veins, and coins and fragments of coarse pottery have been found on their spoil heaps. Roman remains have been found in abundance in the neighbourhood of Eyam and Stoney Middleton.

The Romans would have been familiar with Eyam.

Replica pigs of lead in Buxton museum.

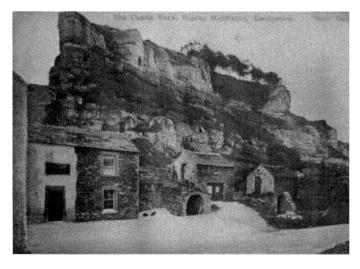

Castle Rock on the Eyam–Stoney Middleton border was believed to be the site of a Roman fort.

Around the end of the eighteenth century, Joseph Slinn and William Redfern discovered an urn near Bolehill, on Eyam Moor, and although Slinn wanted to secure it intact, Redfern smashed it to pieces to see whether it contained treasure. It contained ashes and two Roman coins. In 1814, some labourers employed in burning limestone in Eyam Dale found a great quantity of silver and copper coins bearing the inscriptions of Roman emperors, such as Probus, Gallienus and Victorinus, alongside shards of pottery and a pair of silver armilla – now in Weston Park Museum.

Derbyshire lead was exported through the Trent ports at the time of Edward the Confessor and dubious though it may seem, there is a legendary charter granted to the miners of Eyam by King John giving them sweeping rights to search and mine for lead anywhere within the village with the exception of church and private land.

Lead mining has been carried out in the Eyam area since Roman times.

Eyam Church

Did You Know
St Lawrence, Feast Day 10 August, one of the most venerated Roman martyrs and celebrated for his Christian valour, died 258 in Rome.

Eyam, like many villages that centred around the lead mining industry, is still governed by the same lead mining laws and customs that have existed for centuries, administered through its own mining court, or Barmote Court with its twelve jurymen, steward, and Barmaster who is executive officer of the court. Lead royalties and mining rights are still dealt with by the jury and the officers of the court, which is held once a year. Stimulated by demand during the sixteenth and seventeenth centuries, lead mining expanded to become a major industry in the limestone country of Derbyshire. Lead mining has been fundamental to Eyam's prosperity for over 2,000 years.

This was a mining and farming community with many families having livestock and working an adit. Most of the small, scattered fields in Eyam were grassland for cattle, sheep, and cereal crops. The villagers would have grown oats, a crop that suited the harsh Pennine landscape and which became a major part of the people's diet.

Did You Know
Derbyshire Oatcakes are made from a yeast-based dough and were traditionally cooked on a bakestone, a suitably selected gritstone able to withstand great heat.

Religion has always been at the centre of this community, as can be seen by the eighth-century Celtic Cross, one of the finest of its period. It is rich in quaint carvings, rudely sculptured figures of angels bearing crosses and blowing trumpets, and its sides

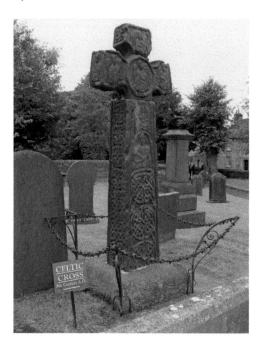

The eighth-century Saxon cross in Eyam graveyard.

are curiously adorned with scroll-work and interlacings. Undoubtedly there would have been a Saxon church here because evidence of the earliest church can be found in the current church. There is a Saxon font, a Norman window at the west end of the north aisle, and Norman pillars that are thought to rest on Saxon foundations. The site of the present church has therefore existed as a place of worship since Saxon times, yet there is no mention of a church or a priest at Eyam in the 1086 Domesday Book.

The Staffords and Their Strange Tenure
The first indication of a church building is the chapel of St Helen said to have been founded by the very wealthy Stafford family of Stafford Hall, who owned much land and property around Eyam.

Did You Know
St Helen was born around AD 270 and was the mother of Constantine, who later became the first Christian Emperor.

Although some historians believe that the Staffords acquired their land through marriage with the Furnivals, according to old deeds, the tenure was granted to the first of the Staffords by King John who reigned between 1199–1216, but there were certain

conditions attached. They had to keep a lamp permanently burning on the altar of St Helen's Chapel, now incorporated into the present church as the north aisle.

This would seem no big deal for a wealthy family with many servants to do such a task, but this peculiar tenure stated that the procedure must be supervised by the actual male possessor or his heir. In default of male issue, an heiress could perform the task provided that she was unmarried, because on her death or marriage all the land would pass from the family back to the Crown.

So the original church and the Stafford family were linked by this strange tenure and by around 1350, the Norman structure had been replaced by a church with a chancel and north and south aisles, all much smaller than they are today. This may have been when the church was dedicated to Saint Lawrence, a Christian preacher who, when asked by the Prefect of Rome to hand over the treasures of his church, presented his people. Angry at being tricked, the Prefect ordered Lawrence to be put to death by being tied to a grid iron and roasted. St Lawrence's badge is a grid iron.

Skipping a few centuries, the Staffords were still residing at Stafford Hall, said to have been built during the reign of Henry VI (1422–61). It was described as a spacious and massive building, the greatest proportions being in length. From the middle of the principal or southern front of the exterior of the mansion projected a large circular stone on which was carved the Staffords family arms – a chevron between three martlets. In the interior, the rooms were all floored with black oak, which although of a mirror-like brightness, contributed to the sombre, gloomy appearance which was principally caused by the narrow windows.

Around the middle of the sixteenth century, Stafford Hall was the home of Humphrey Stafford. He had five daughters – Margaret, Alice, Gertrude, Ann and Katherine – but his two sons – Humphrey and Roland – had died in their youth. His wife had also died, and despite the fact that Humphrey Stafford needed a legitimate male heir to inherit his vast estates, he had no wish to remarry. Katherine had married Rowland Morewood of Bradford, Yorkshire; Gertrude had married a lineal ancestor of the Earl of Newburgh,

Stafford Hall

Stafford Hall was sited on Hawkshill, a name taken from the popular sport of hawking, carried out here by the Staffords.

Hassop; Alice married John Savage of Castleton; Ann married Francis Bradshaw; but Margaret refused all suitors and remained at Stafford Hall with her father. Between them, they tended the lamp on the altar of St Helen's Church.

Did You Know
A local legend states that the Stafford family was granted the tenure of Eyam by King John (1199–1216) on condition that they tended the lamp of St Helen that hung in the church. They continued to fulfil this requirement until 1603 when King James gave them a pardon.

The Intrigue and Involvement with Mary, Queen of Scots

It was March 1565 when they received news that the unfortunate Mary, Queen of Scots (1542–87) had just arrived under house arrest at nearby Chatsworth House under the care of George Talbot, the 6th Earl of Shrewsbury, and his wife, better known in history as Bess of Hardwick. The Staffords made plans to visit Chatsworth to show their respect, and their loyalty and admiration for the captive queen left a deep impression. As the Earl of Shrewsbury and his wife Bess of Hardwick remained her captor until 1584, the Staffords probably saw the captive Queen on various occasions as she was moved around their palatial Derbyshire homes.

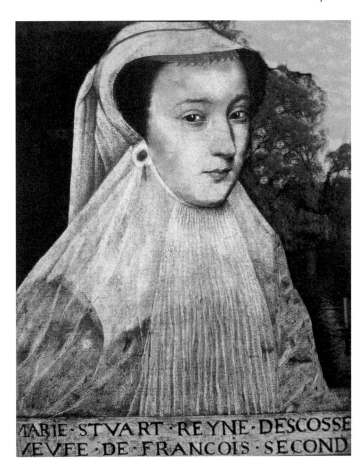

MARIE · STVART · REYNE · DESCOSSE
ÆVFE · DE · FRANCOIS · SECOND

Right: Mary, Queen of Scots was imprisoned nearby, and was visited by the Staffords.

Below: Chatsworth House in Tudor times.

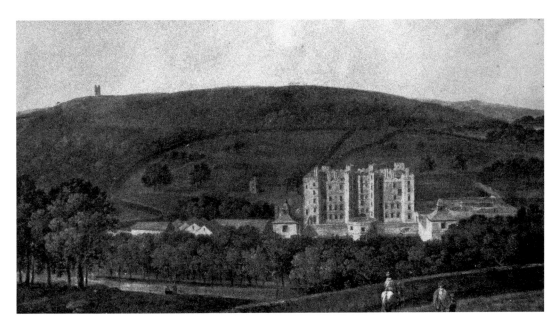

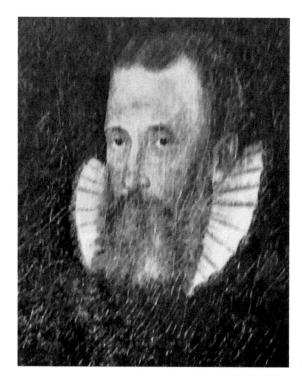

George Talbot, 6th Earl of Shrewsbury.

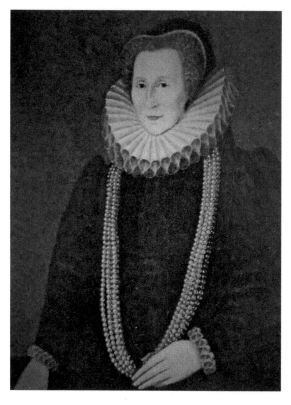

Bess of Hardwick, Countess of
Shrewsbury.

Above left and right: Queen Mary's Bower, Chatsworth, the belvedere where the queen was allowed to take exercise outdoor.

Queen Mary's Bower.

In an age when people communicated regularly through letters, it was understandable that Margaret Stafford should write about her concern for the plight of the unfortunate queen. One such letter was sent to her friend Anthony Babington, son of another prominent Derbyshire family who, like the Staffords, were actively involved in lead mining in the area. They owned a country house at Dethick near South Wingfield, and Babington Hall, a town house in the centre of Derby. Demolished in 1826, it stood opposite the Babington Buildings on the north-west corner of Babington Lane where on the gable is carved the family crest, a baboon on a tun or barrel.

At the age of ten, Anthony Babington had been made ward of George Talbot, the 6th Earl of Shrewsbury, and in 1569, when they were given custody of Mary, Queen of Scots, Anthony Babington became page to the twenty-six-year-old Scottish queen and grew infatuated by her. Like all Catholics, Anthony Babington considered that Mary, as the great-granddaughter of Henry VII, should be the rightful queen of England. With the help of John Ballard, a Catholic priest from Rheims, and five others, Anthony Babington planned to murder Queen Elizabeth and put Mary on the throne.

Humphrey Stafford died and a cloud of deep despondence overshadowed the village and in a large tapestried room at Stafford Hall, the last of the Stafford name was laid in his coffin of black oak before being carried to the village church. There, the coffin was carried once round the cross in the belief that this would procure a more speedy release of the soul from purgatory – a Popish custom which was practiced long after the Reformation, even by Protestants. Finally, Humphrey Stafford was laid beneath the northern aisle of the little church.

After the funeral, many of the villagers went to the Shrewsbury Arms which stood opposite the church. It was kept at this time by Lawrence Decket, who combined his occupation as landlord with that of village blacksmith.

Did You Know
Margaret Stafford was a friend of Anthony Babington and could have been implicated in the plot to place Mary, Queen Of Scots on the English throne.

Anthony Babington Saves Margaret Stafford

It was here around two years later, in 1585, that a messenger arrived in some haste. After talking to Decket, they both hurried up to Stafford Hall where the messenger handed Margaret Stafford a letter from Anthony Babington. Prior to his arrest on 20 September 1585, his subsequent torture and death, Anthony Babington with a purse of gold had induced a friend to warn Margaret Stafford that the letters which she had written to him expressing her deep sympathy for Mary, Queen of Scots had been found amongst the Queen's papers. Her enemies had decided that the Staffords were involved in the conspiracy to free her, kill Elizabeth and place Mary on the English throne, so they had obtained a warrant for the arrest of Humphrey and Margaret Stafford.

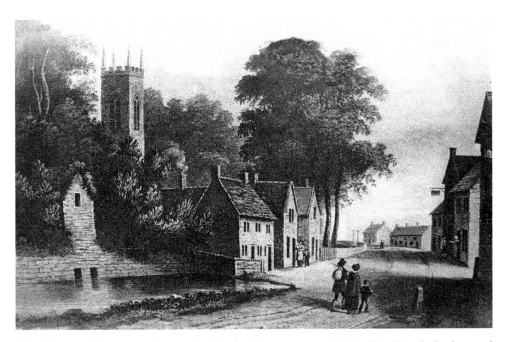

The village pond known as the Eaver, beside the plague cottages with the church in the background and the swinging sign of the Shrewsbury Arms opposite.

The faithful Decket helped conceal Margaret Stafford in what was known as the Salt Pan, a very secluded, long, deep chasm in the Delph where it would be impossible for anyone not acquainted with the labyrinth to find her. Hardly an hour had passed before four armed men arrived in Eyam and dismounted at Stafford Hall with the warrant. They were informed of the death of the master but that made them even more determined to find the mistress of the house. They ransacked the hall, searched every property in the village and threatened the people with instant death if they did not disclose the whereabouts of Margaret Stafford, but no one spoke because only Decket knew where she was.

True to his word, at the first opportunity he conveyed her away to an isolated cottage at Gother Edge (now Gotherage) on the edge of Eyam Moor. The word 'gother' is Celtic and means red or red edge – quite descriptive of this place. For eighteen years this poor, unhappy woman lived in hiding supported by the loyal villagers, but at the dead of night, she ventured back into the village where she would visit the church to tend the lamp of St Helen.

It was not until the death of Queen Elizabeth in 1603 that it was safe for Margaret Stafford to return to Stafford Hall, by which time she was a shadow of her former self. Her plight was related to Elizabeth's successor King James, who asked how she could be recompensed for her years of depravation, and she humbly requested the annulment of the tenure by which her forefathers had held their land at Eyam, the tending of the lamp of St Helen. The monarch ordered that to be done immediately and the lands of the Staffords were to be inherited by the co-heiresses of Humphrey Stafford and their heirs for ever.

Margaret Stafford become a much-loved village benefactor and amongst her other works of charity, she erected the church's new tower and four bells and had the nave

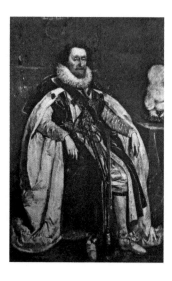

King James cancelled the tenure and ordered that the Staffords were to inherit their Eyam lands forever.

decorated with murals depicting the twelve tribes of Israel. A bell dating from 1628 is still one of the six bells.

Margaret Stafford was interred beside her father near the northern aisle of the church, and thanks to her, Stafford Hall passed to her sister Anne, daughter and co-heiress of Humphrey Stafford who in 1565 had married Francis Bradshaw, family of the notorious Judge John Bradshaw who sentenced Charles I to death. It was their great-grandson, also named Francis, who in around 1611 built a three-storey extension on the east side of Stafford Hall and changed the name to Bradshaw Hall.

Eyam and the English Civil War

When King James I of England (VI of Scotland) died in 1625, his son Charles I came to the throne of a country that was going through many changes. The power of the extreme Protestants or Puritans was growing, the country squires and landowners were demanding more say in running the country, but Charles I treated them all with disdain. He believed in a king's right to rule by the will of God, and between 1629 and 1640 he summoned no parliament, and brought in unpopular taxes, religious reforms and unrest which led in 1642 to the English Civil War.

In 1643, an Act of Parliament specified that all public crosses should be removed and destroyed because they were employed in every sacred ritual, designed to excite sentiments of piety or compassion and reverence. Originally placed by the wayside, these crosses served as boundary markers and were used by itinerate priests and monks to preach from. The cross was frequently placed on the highway to deter highwaymen and restrain other predators in the same way that in the marketplace, the market cross was an indicator of upright intentions and fair dealings.

Although the 1643 Act ordered their destruction, many crosses were saved by locals circumventing the wishes of parliament by concealing them with the intention of re-erecting them when the government policy changed. In the Ecclesiastical Parish of Eyam, the eighth-century village cross was saved and later placed in the churchyard where it still stands.

Did You Know
The striking Saxon cross in Mercian style dates to the late eighth or early ninth century and originally stood at Cross Low, west of Eyam, where it probably served as a wayside preaching cross. It was discovered beside an ancient trackway during the eighteenth century, dug up, and erected in the churchyard at Eyam. Now around 8 feet high (2.4m), it was originally as much as 10 feet (3m) tall, but has lost a section of the cross shaft. It's the only Saxon cross in the Midlands that retains its cross-head.

The commander of the Parliamentarian forces was Oliver Cromwell, and it was Sir John Gell of Hopton Hall who controlled the Parliamentary forces in Derbyshire and helped ensure Cromwell's victory. Many of the gentry in Derbyshire remained loyal to the King and the old order; so much of the action centred on the control of the Royalist military strongholds like Bolsover Castle and Wingfield Manor. William Cavendish, 3rd Earl of Devonshire, grandson of the previously mentioned Earl of Shrewsbury and Bess of Hardwick, who lived at Chatsworth House held high office in Derbyshire and neighbouring counties. As a keen Royalist supporter, he opposed the government, absented himself from his place in Parliament, was expelled and committed to the Tower of London but escaped to the Continent.

Oliver Cromwell.

John Gell of Hopton Hall, head of the Parliamentarian troops in Derbyshire.

William Cavendish, 3rd Earl of Devonshire.

King Charles II.

Playing cards was considered to be the devil's work.

Even the peaceful village of Eyam was not so peaceful. Like many grand country houses, there is every possibility that Bradshaw Hall was partially destroyed during this time. Following his misfortunes as a keen Royalist, in 1662/3, Sir George Saville, Lord of the Manor of Eyam, had to sell off most of his landholdings. At this time, the old Manor of Eyam was very much larger than the present township, encompassing Foolow to the west, Eyam Woodlands which also encompassed part of Grindleford and part of Stoney Middleton to the east, with Middleton Dale Brook forming the southern boundary. The 1662/3 division caused a radical change.

The Civil War affected every social aspect of life throughout the country. Churches were closed, their contents desecrated. Lead was peeled off the roofs and melted down to be made into cannonballs and fighting implements. Lead coffins suffered the same fate. Marriages were conducted before a Justice of the Peace; disputes erupted over respective prerogatives, families were split and neighbours fought neighbours.

Within the church at Eyam, the tolerance of the Revd Shoreland Adams, the rector, was also being tested to the full. His loyalty to the King and support of the Royal cause didn't go unnoticed and in 1644 he was seized, deprived of his living and cast into prison.

The successor of Revd Shoreland Adams was the virtuous non-conformist minister the Revd Thomas Stanley. We know very little of his private life except that he was born at Duckmanton (near the Royal Hospital in Calow), Chesterfield and was married with at least one son, named John.

William Cavendish returned from the Continent in 1645 when he was pardoned but heavily fined; then, on 30 January 1649, Charles I was executed. The nation was now a republic or Commonwealth and Parliament ruled the land with Oliver Cromwell taking control as Lord Protector. Many of his supporters were Puritans; the only joy they could accept was through religious worship. Fashionable dress, frivolity, dancing and theatre were banned, and playing cards was believed to be the work of the devil.

The Return of the Monarchy and Disruption in Eyam

Then in 1660, Parliament finally asked Charles II to return from exile and be crowned King of Great Britain and Ireland. The monarchy was restored and although there was much rejoicing, this brought more problems for Puritans like Revd Stanley. He and several

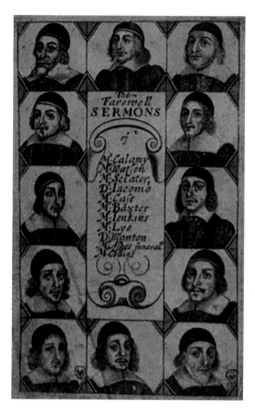

Front page of the farewell sermons preached by Puritan vicars like Thomas Stanley.

thousand other Puritan ministers refused to acknowledge the 1662 Act of Uniformity, which made it compulsory to use the Book of Common Prayer, introduced by Charles II, in religious services. This led to the great ejection of Puritan vicars throughout England. Thomas Stanley was forced out of his position in the church, and the Revd Shoreland Adams was reinstated.

The villagers were divided in their support for the two clergy, particularly as Thomas Stanley remained in Eyam acting as Curate, ignoring the sneers and jibes of his bitter enemies until he resigned in 1662. His wife died in Eyam on 14 June 1664 and is buried in the churchyard.

This was the situation when the Revd Shoreland Adams died in 1664, and a young curate named William Mompesson arrived in Eyam. The earliest reference to William Mompesson (1639–1709) is in *Alumni Cantabrigienses*. William's family was from Scalby in North Yorkshire. He was baptized at Collingham, West Yorkshire, on 28 April 1639, attended school in Sherburn and went to Peterhouse, Cambridge University, in 1655. He graduated BA 1659 and MA 1662. He was ordained in 1660 and after a period of service as chaplain to Sir George Saville, later Lord Halifax, he came to Eyam as Rector with his wife Catherine, daughter of Randolph Carr of Cocken in the county of Durham, and their two young children, George and Elizabeth. The villagers welcomed the new curate and his young family and looked forward to a period of calm after such a changing pattern of life, but that was not to be.

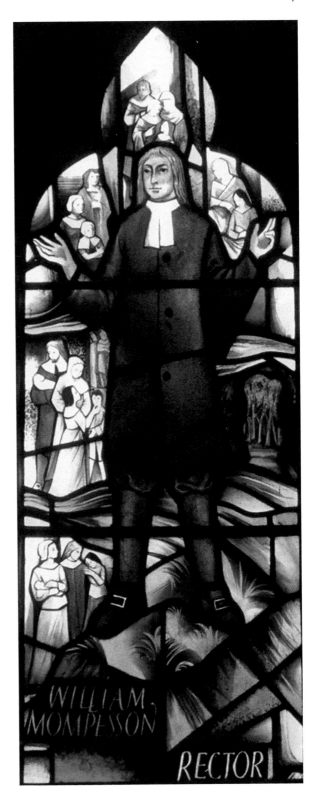

William Mompesson in the Plague
Window in Eyam Church given
in 1985 by Mrs C. M. Creswick.
Designed and executed by
Alfred Fisher.

2. The Deadly Bubonic Plague Arrives in Eyam

The year was 1665. The monarchy was back with King Charles II on the throne, but London was in the grip of the bubonic plague, a deadly disease that came to England along the trade routes from the Netherlands, where the disease had been occurring intermittently since 1599. No event in British history had a more cataclysmic effect on the life of the people since the shocking outbreak of the plague known as the Black Death in 1348/49.

We know of this through writers of the time, and it's interesting to look at it from the viewpoint of Samuel Pepys, one of the most colourful and appealing characters of the seventeenth century. He witnessed many of the great events that shaped Stuart Britain, and brought them to life in his famous diary. He saw kings fighting for their crowns, the devastation of medieval London by plague, fire and war, and its resurrection as a world city.

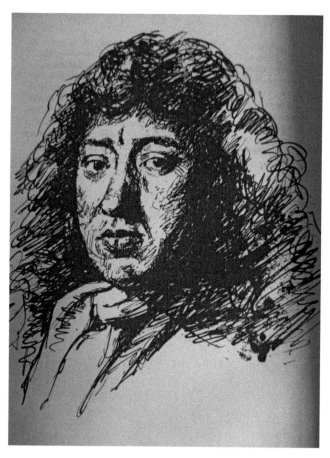

Samuel Pepys.

A famous diary.

On 26 November 1663, Pepys tells us that

> the plague grows more and more in Antwerp ... we are going upon making of all ships coming from thence and Hambrough, or any other infected places to perform their Quarantine for thirty days ... a thing never done by us before.

On 4 May 1664 he makes another comment about the plague at Antwerp increasing, and it's almost certain that it was around this time that it arrived in England with Dutch trading ships carrying bales of cotton.

The Padley Martyrs
On 7 June 1665, while walking down Drury Lane, Pepys saw

> two or three houses marked with a red cross upon the doors, and – 'Lord have mercy upon us!' writ there; which was a sad sight to me, being the first of the kind that to my remembrance, I ever saw. It put me into an ill concept of myself and my smell, so that I was forced to buy some roll tobacco to smell to and chaw (sic) which took away the apprehension.

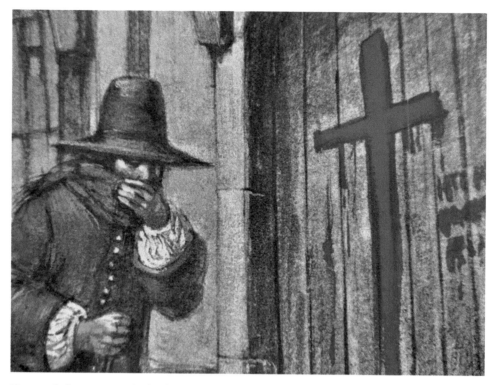

Houses of plague victims had red crosses on their doors.

Did You Know
The diarist Samuel Pepys' first realisation that the plague had arrived in London was when he saw red crosses on several doors. If anyone in the household showed symptoms of the plague, it was compulsory for the whole household to remain indoors and to paint a red cross on the door to alert the neighbourhood. He bought tobacco to smell and chew as this was believed to be a remedy to combat the plague.

The Significance of Tobacco

It's said that Sir Walter Raleigh brought tobacco to England from Virginia in 1586 but it's more likely that Sir John Hawkins and his crew brought it to these shores twenty years earlier. The use of tobacco by this time was well known on the Continent, with Spanish and Portuguese sailors smoking tobacco, a habit likely to have been adopted by British sailors. The Spaniard Nicolas Monardes had written a report on tobacco, translated into English by John Frampton in 1577 and called Of the *Tabaco* and of *His Greate Vertues*, which recommended its use for the relief of toothache, falling fingernails, worms, halitosis, lockjaw and even cancer.

Smoking tobacco became a habit.

When Raleigh brought tobacco, maize and potatoes to England in 1586 he started a smoking craze at Court. It's said that he tempted Queen Elizabeth to try smoking, yet rather bizarrely, although tobacco was seen as good for health, potatoes were viewed with great suspicion.

The habit of smoking was copied by the population as a whole and by the early 1600s the habit was commonplace. But Queen Elizabeth's nephew, James l of England (James VI of Scotland), who inherited her throne in 1603, saw smoking as a cause for concern, and imposed an import tax on tobacco. In 1604 he wrote *A Counterblaste* to Tobacco, in which he described smoking as a

custome lothesome to the eye, hateful to the nose, harmful to the brain, dangerous to the lungs, and in the black and stinking fume thereof, nearest resembling the horrible stygian smoke of the pit that is bottomless.

Did You Know
The Catholic church tried to discourage the use of tobacco by declaring its use to be sinful and banning it from holy places. Yet despite these warnings, the use of tobacco continued to grow. In 1638 around 3,000,000 pounds of Virginian tobacco was sent to England for sale and with the Restoration of Charles II in 1660 came a new way of using tobacco as snuff. Taking snuff became the aristocracy's favourite way of enjoying tobacco. Then came the Great Plague of 1665 and tobacco smoke was widely advocated as a defence against 'bad air'. At the height of the plague, smoking a pipe at breakfast was actually made compulsory for the schoolboys of Eton College, London.

The Plague Arrives in the City of London

On 10 June 1665, Samuel Pepys states that 'officially the plague has come into the City, (Fenchurch Street) though it hath, these three or four weeks since its beginning been wholly out of the City'. On 21 June, he writes 'I find almost all the town is going out of town, the coaches and wagons being all full of people going into the country.'

In response to the plague outbreak in London, there were at least forty-six pamphlets and books published between 1665 and 1666, reflecting the great anxiety of Londoners at this time. They sought advice on how to avoid or combat the infection, and information on the level of mortality. As illness was frequently attributed to divine intervention, people needed to focus on preparing their souls for the world to come. These books were like newspapers – to facilitate the rapid dissemination of information and be replaced regularly with more up-to-date statistics and advice.

The frontispiece of *The Christians Refuge* shows the figure of a skeleton and other macabre images associated with the plague. The skeleton wears an ermine cloak, a crown and a sceptre showing that everyone, including royalty, are defenceless against the plague. The skeleton also holds an hourglass and there are worms crawling on its bones. The four lines of verse below the skeleton read: 'Death triumphant cloth'd in Ermine/ 'Bout whose bones do crawl the Vermine/ Doth denote that each condition/ To his power must yield

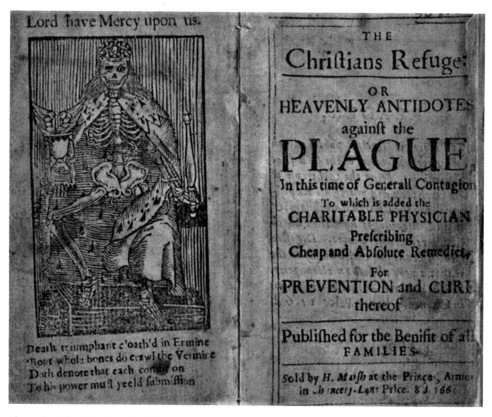

Plague booklet *The Christian's Refuge.*

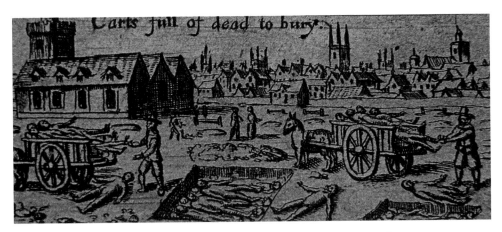

As the number of dead increased, mass burials became the norm in towns and cities.

submission.' The final section lists a number of remedies to combat the plague, such as, 'Take the Topes of Rue a Garlick-head, or half a quarter of a Walnut, and a corn of Salt, eat this every morning continuing so a moneth together, this is also good against the worms in young and old.'

It does however issue the warning: 'yet trust not so much in the Physick [the practice of medicine] as in the blessing of God, without which all Physick is uneffectuall'.

As the number of dead increased, on 12 August Pepys writes that 'now it seems they are fain to carry the dead to be buried by daylight, the nights not sufficing to do it in. My Lord Mayor commands people to be within at nine at night all, as they say, that the sick may have liberty to go abroad for air'.

Also that day he writes that ' the King and Queen are speedily to be all gone to Milton. So God preserve us all!' The following day Pepys wrote his will, 'so that I shall be in much better state of soul I hope if it should please the Lord to call me away this sickly time'.

On 16 August, he wrote 'But Lord! How sad a sight it is to see the streets empty ... and about us two shops in three if not more, generally shut up.'

On 28 August he wrote, 'but now how few people I see and those looking like people who had taken leave of the world'.

Three days later, as Pepys and his household moved to the relative safety of Woolwich where the air was thought to be cleaner, he wrote 'the plague having a great increase this week, beyond all expectations ... thus this month ends with great sadness upon the public, through the greatness of the plague everywhere through the kingdom almost'.

The Plague Arrives in Eyam

Although the previous statement confirms that Pepys was aware that the plague had spread to numerous places throughout the kingdom, it's doubtful that he had ever heard of a tiny Peak Land village known as Eyam. He was not to know that the great sadness he spoke of was about to descend on this remote village 160 miles from London. He was not to know that a box of contaminated cloth had been sent from London to Eyam in August 1665 for a journeyman tailor named George Vicars. Very little is known of George Vicars,

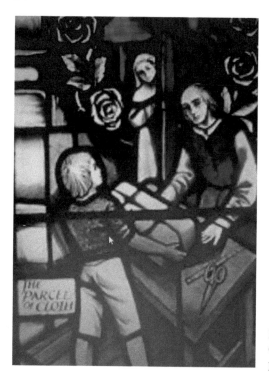

Part of the stained-glass window in Eyam Church showing George Vicars accepting the parcel of contaminated cloth.

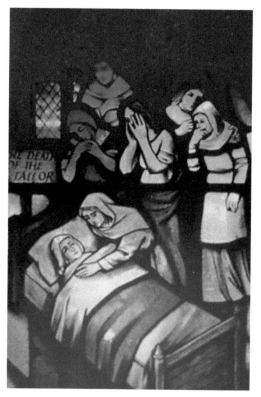

Part of the stained-glass window showing the death of the tailor.

but as a journeyman he had completed his apprenticeship and was qualified to hire out his services by the day (from the French journee) or the week. George Vicars accepting the parcel of cloth is told in simple graphic terms in the magnificent stained-glass Plague Window in Eyam Church.

The traditional tale says that George Vicars lodged at the home of Mary Cooper, a widow with two small sons – Edward, aged three, and Jonathan, twelve. Recent research has uncovered that in March 1665, approximately five months before the outbreak of the plague, Mary Cooper married a tailor named Alexander Hadfield. George Vicars was his assistant or servant who was given the task of unpacking the cloth. Because it was damp, George spread it out in front of the fire to dry, but the heat revived the fleas that were hibernating in the layers of cloth.

September arrived in Eyam with all its bounty. This was a rural community; there would have been a bumper fruit crop from orchards and hedgerows. Land at village level was either pasture or yielded oat crops and the harvest was good. The people gave thanks with harvest festivals. The village windmill would be busy grinding the oats to make the flour from which oatcakes were made. Oatcakes, cheese and ale would have been the staple diet of most villagers during this period. The people of Eyam would not go hungry that winter.

Did You Know
In London, even when the plague was at its height, Pepys was more interested in making notes about his own day-to-day life than the ongoing calamity. It was 3 September, and being the Lord's Day, he had put on his very fine, colourful silk suit and his new periwig and then pondered on what would be the new fashions after the plague was over. There would be no new periwigs – 'for nobody will dare to buy any hair for fear of the infection that it had been cut off the heads of people dead of the plague'.

At the same time that Samuel Pepys was pondering about the latest fashions, George Vicars became ill and on 7 September 1665, he died an agonising death. The second death was three-year-old Edward Cooper, who was buried on 22 September. The cottage where these first deaths occurred has become known as Plague Cottage. Next door was the Hawksworths' cottage. Peter Hawksworth was the third person to die and was buried on 23 September. His wife Jane was three months pregnant and although she survived and later married William Ainsworth, another survivor, her fourteen-month-old son Humphrey was the eighteenth person to die, on 17 October, and her baby, born in March, died after two days.

At the other side of the Plague Cottage is Rose Cottage where nine members of the Thorpe family died between 26 September 1665 and 2 May 1666. As more deaths followed, the dreadful facts became clear; Eyam had been struck by the deadly plague.

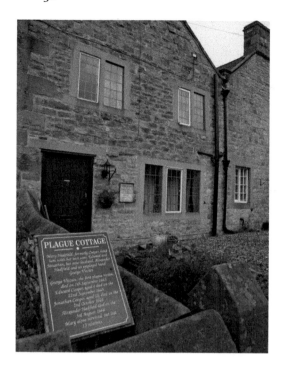

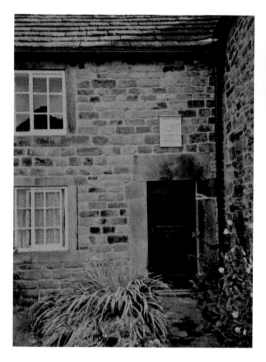

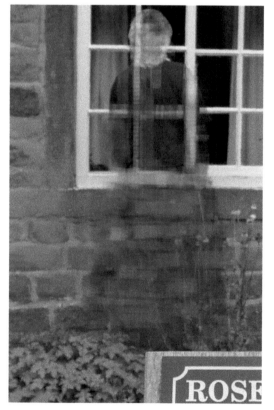

Below left, above right and Left: Plague cottages where it all began, and the ghost of times past.

The popular belief is that the people were told to stay within the village by the Revd Mompesson, but wealthy residents like the local squire, the more affluent landowners and the mine owners who had somewhere to go would have left in a hurry. They would not be dictated to by a young curate who had only just arrived in the village and had sent his own children to safety in Yorkshire in June 1666, just before the quarantine was agreed. Although he wanted his wife to go with them, she refused.

There is every possibility that Bradshaw Hall had been partially destroyed during the Civil War, because sadly it never appeared to be the Bradshaws' family home after that, and when plague broke out in 1665, the widow and daughter of Squire George Bradshaw left Eyam permanently for Brampton in Yorkshire.

There is no record of how many people actually left the village but we can assume that most of the villagers would have stayed because they had nowhere else to go. They would never have ventured outside the village throughout their whole lives, so the thought of leaving their familiar surrounding would have been as frightening as the plague. Even if they had relatives or friends outside the area, it would be questionable as to whether they would get an affable reception or be able to take refuge there.

Did You Know
A young woman from Eyam had, just before the plague, married a resident of Curbar where she had taken up residency, but her widowed mother was still in Eyam. The young woman secretly visited the stricken village and on the last occasion found her mother dying of the plague. She returned hastily to Curbar, but within two days had herself developed the fatal symptoms and died in agony. To the great relief of her neighbours many of whom remembered how the plague had raged in Curbar thirty years previously, the disease did not spread.

This was a rural community; it was impossible for the farmers to leave their cattle or the shepherds to leave their sheep. Some of the villagers moved out of the close confines of the village and built temporary shacks and huts along Edgeside, beneath the rocks in Farnsley Lane, in the Delph, or in the fields near Riley. This area between Eyam and Stoney Middleton was formerly common land where isolated huts were built for the accommodation of the plague victims. If more villagers had shut up their cottages and camped on the hillside, the number of deaths would have been reduced dramatically, but that's easy to say with 350 years of hindsight.

Villagers tried to find alternative accommodation in caves and huts.

Did You Know
The small stone building on the village green was the market hall but as the clergymen advised that plague victims should be removed from their homes into huts or barracks built upon the common land, it could have been the site of a hostel for nursing the sick during the plague.

Did You Know
Andrew Merrill, who lived at Hollins House, survived the plague by going to the summit of Sir William Hill Road and building a crude hut in which he lived with his pet cockerel until the plague was over.

The Wrath of God

These were simple, God-fearing folks and with no scientific or medical knowledge they believed that the disease was the wrath of God, visited upon the sinful people, a divine punishment that had to be endured. They looked for ways in which they had angered God and pondered on their sins. It was recalled how village lads had allowed some cows to enter the church and foul the nave while a Wake service was in progress. Was this enough to invoke God's wrath?

Similar analyses were reflected in Thomas Vincent's book *God's Terrible Voice*. Thomas Vincent was a dissenting minister in London who had lost seven family members and was deeply immersed in the horrors of the plague, yet in his book, he is far more interested in the biblical side than the facts, linking events to 'sinning drunkards and swearers'.

No wonder the villagers questioned what they had done to provoke God's wrath. Was it because of the alleged curse put on Eyam after the villagers had verbally abused two recusant Roman Catholic priests passing through the village on their way to perform clandestine mass at the chapel at Padley Hall in 1588. This was a time when many local Catholic families suffered for their faith; heresy was rife and punishable by death, so many practiced their faith covertly. Being Catholic carried considerable risks and the fate of Nicholas Garlick, Robert Ludlum and Richard Simpson collectively have gone down in history as the Padley Martyrs. Nicholas Garlick was a local man from Glossop who, with Robert Ludlam, was found hiding in a priest hole at Padley Hall near Grindleford, the home of the Fitzherberts, now destroyed. Richard Simpson, alias Gayle, was apprehended elsewhere. These three unfortunate priests were branded as traitors, tried and found guilty of high treason. They were sentenced to be hanged, drawn and quartered. The sentence was carried out on 24 July 1588, and after spending their last night in the Bridge Chapel on St Mary's Bridge, Derby, they were executed on the bridge. The dismembered bodies of the Padley Martyrs were impaled on spiked poles on the

town side of the bridge as a deterrent to others. Now every year, a pilgrimage is held to commemorate the bravery of the Padley Martyrs, with a short walk followed by a mass at Padley Chapel.

Did Meteors Predict the Plague?

Some talked about the meteor that had previously been visible in the sky and was interpreted by superstitious villagers as an omen of disaster. There were two comets prior to the plague and the Great Fire of London, one in 1664, the other in 1665. The people believed that they were fiery messengers of the heavens – a direct line from God. They were an indication of his irritation with humanity and a heavy hint that something extremely unpleasant was bound to follow – fire, war or plague.

These were not just the ramblings of the superstitious villagers of Eyam. They can be confirmed by that great writer of the time Samuel Pepys, when on 15 December 1664, he gives this account of a comet seen above London: 'To the Coffeehouse, where great talk of the Comet seen in several places; and among our men at sea, and by my Lord Sandwich, to whom I intend to write about it to-night.'

A few days later, he reports that there is much talk about the comet having been seen by many including the King and Queen. Pepys hoped to see it for himself, so on 17 December he wrote that 'I thought to have done so too, but it is cloudy and so no stars appear.'
On 21 December, Lord Sandwich wrote to Pepys that he had seen the Comet at Portsmouth and it was the most extraordinary thing that ever he saw.'

On 24 December at 2 a.m. Pepys is told that the star is seen upon Tower Hill and hurries there to see it, 'It being a most fine, bright, moonshine night and a great frost but no comet to be seen.'

Sir Isaac Newton, a student at the time, searched the skies for the comet. Daniel Defoe mentions it in *his Journal of a Plague Year* written over 100 years later, but Defoe obviously relied upon his imagination and borrowed liberally from the work of earlier writers who had witnessed the events.

Understandably, astrologers were quick to interpret the meaning of these comets and other irregular, sporadic signs. A physician named Nathanial Hodges wrote a book entitled *Loimologia*, first published in Latin in 1672 and translated in 1720. The book states that the predictions of astrologers 'spread fear among the meaner sort of people and so rendered their constitutions less able to resist the Contagion'. An interesting theory from a physician whose own science is rather questionable when he writes, 'it is clear as Light at Noon-Day that the Pestilence is a disease arriving from an Aura that is poisonous, very subtle, deadly and contagious, affecting many Persons at the same Time together in one Country chiefly arriving from a Corruption of the nitrous Spirit in the Air, attended with a Fever and other grievous symptoms'.

Hodges also gives a remarkable first-hand account of seeing the black hue of the buboes on a young man in fever, the public health measures taken to protect the trembling inhabitants from calamity, and the unscrupulous quacks who tried to profit from this calamity.

Above and below: The sighting of a comet was said to forecast major events.

Did Nostradamus Predict the Plague?

The French preacher Nostradamus was considered to be the most powerful seer of the time and wrote his predictions in a form of mystic passages known as quatrains, the bulk of which were published in 1555 in his magnum opus *Les Propheties*. It's claimed that many of his predictions have come true, including the Great Fire of London, yet there is no specific mention of the Great Plague. However, he predicted that humanity would suffer from a serious illness, which would be difficult to destroy, so this could refer to the Great Plague. However, over the years, his writings have been exploited in a number of fallacious ways. Ambiguous and wrong translations, hoax writings, and the breaking of non-existent codes within his quatrains all contribute to a vast body of work many times the size of anything Nostradamus ever actually wrote.

Did You Know
Some 500 years ago, the famous seer Nostradamus predicted a serious illness that would be difficult to destroy. This may have been the Great Plague, but in 2020, many now link this to the coronavirus. He is also credited with predicting global warming, but creative interpretations and fictional accounts must be taken into account when considering Nostradamus-supposed prophesies.

Strange Omens and Prophecies

The people of Eyam made their own predictions. Some remembered that they had heard the sound of the Gabriel Hounds or gabble ratchets as they hovered over the moor above the village. The belief in the appearance of the Gabriel Hounds was very strong in the Peak District and was supposed to be a sure sign that death would soon visit the neighbourhood.

Crickets played a big part in superstitious beliefs and when someone said that white crickets had been seen on domestic hearths this was said to predict misfortune. Normally the presence of crickets in the kitchen or near the hearth would be considered a good omen, but as crickets are usually black or brown, the white version was obviously considered a bad omen. A strange cricket in the house was seen as an unfailing sign of death. How 'strange' is defined is obviously open to interpretation, and left to the individual. If a cricket departs from a hearth where it has been heard chirping for a long time, that signals misfortune. As it's only the male cricket that produces the chirping sound by the friction of their wings rubbing together for various mating scenarios, female crickets do not have the ability to produce these sounds. If a cricket chirps louder than usual apparently, we should not consider it a sign of sexual frustration, but of expected rain. Then the question was asked 'Did anyone kill a cricket?' That was believed to be bad luck, especially if it was Sunday. That was particularly unlucky.

The superstitious villagers believed in the appearance of the Gabriel Hounds.

The more the villagers thought about it, the more obscure omens were remembered, analysed and accepted as clear indications of doom.

People took to wearing amulets to protect themselves. The word amulet, from the Latin *Amuletum*, is often used with the word talisman, from the Greek *telesma*, meaning mystery. While amulets are solely protective, a talisman also brings good fortune and averts danger. The chief purpose of the amulet was to protect the wearer from the power that caused injury, sickness and death. There were innumerable objects attributed to having the power of amulets, the origins of which are so old, the particular purpose for which they were originally made has been long forgotten, and the power which is exerted remains a mystery.

These people were more interested in effects than causes, but in these days of cold reasoning and scientific research, it is natural that many theories should be formed regarding the nature of these apparently potent influences. Some believe that various objects are capable of giving off certain emanations that not only affect the human body, but also the mind. Radium and the magnetic lodestone are well-known examples. We can understand how it would help if an amulet was made of a material recognised as having such a virtue but how do we explain an amulet that is nothing more than a few words

written on parchment, yet protects against ills. Many people were prepared to accept that an amulet or talisman need be no more than a thought made concrete in the form of words or symbols made for a specific purpose and written on parchment. This becomes to the bearer a continual reminder of its purpose, and undoubtedly strengthens the belief. Implicit faith in an amulet is the first essential if we wish it to benefit us and these simple country people, like the most cultured of ancient people, had that trust along with a belief in some mysterious intangible force that rules the universe.

Both the Revd Stanley and Revd Mompesson were strong in their faith and became the pillars that propped up the anxious community. Their relationship is shown in simple, graphic terms in the magnificent stained-glass Plague Window in Eyam Church.

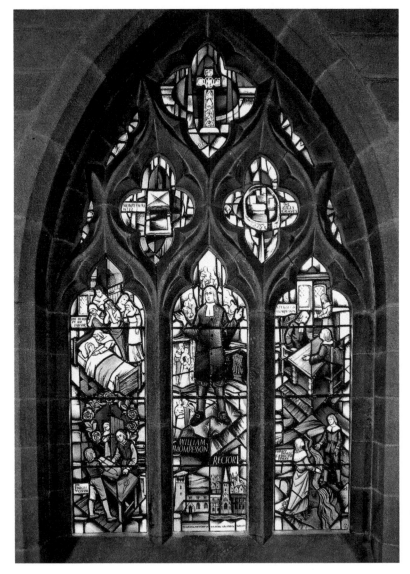

The magnificent stained-glass Plague Window in Eyam Church.

Right: Mompesson and Stanley depicted in the Plague Window.

Below: Infected rats carried the disease.

Fleas that lived on the infected rats carried the plague to people.

They took every precaution to prevent the plague spreading, and the Revd Mompesson dictated his letters to a scribe outside the village for fear that the paper might contain plague germs. Thinking bad air was involved in transmitting the disease, the authorities ordered giant bonfires to be burned in the streets and house fires to be kept burning night and day, in the hope that the air would be cleansed. People believed that the air itself was poisoned and clutched bunches of sweet-smelling flowers to ward off the stench.

The link between the rat as reservoir of infection and host to fleas which could transfer to man was not understood. In hindsight, we find it strange that the people were ordered to destroy their cats and dogs – a decision that had the opposite effect to that wanted. These animals would have reduced the rat population, which would have shortened the length of the epidemic, but instead, without predators, the rats flourished and so did the fleas.

3. The Deaths Continue

There were six deaths in Eyam in September and twenty-three in October, but the cold days of November, which heralded the arrival of a harsh winter, were expected to bring an end to the disease. The winter of 1665/6 was said to have been extremely severe, and it is not difficult to image the village lying silently shrouded in snow. The cottage eaves would be fringed with icicles hanging like daggers, and the walls would be plastered with driven snow. Deep snow drifts would have made the lanes inaccessible, completely sealing off the village from the outside world.

Inside the damp, dark stone walls of these cottages, the noxious earth or stone floors would have been strewn with rushes, leaves and herbs with strong disinfectant qualities like rue and bay leaves, believed to keep the plague 'at bay'. They may have camouflaged the problem, but in an age of poor hygiene, these moist, humid conditions provided a perfect breeding ground with plenty of cover and no shortage of food for the many uninvited, unsavoury creatures including the rats that carried the plague. They would also nest in the thatch and rafters of roofs, providing food for the fleas which in turn would ensure the survival of the plague bacillus.

The winter mortality was less but still above the average and the story of Margaret Blackwell must have brought fresh hope to the villagers.

Villagers would have been isolated in their cottages.

Despite administering medicine to keep the plague at bay, the noxious floors strewn with rushes and herbs would have provided the perfect breeding ground for many uninvited creatures, as shown in this old woodcut.

Anthony Blackwell, the Eyam stonemason, and his wife, Margaret, died just before Christmas 1665, leaving their two children, Francis and Margaret. It wasn't long before fourteen-year-old Margaret started feeling ill and stayed in bed while Francis prepared his breakfast bacon. When he had finished, he poured the fat into a wooden piggin (jug). This would later be used in cooking or making rush lights for illumination. Francis left the house and while away, Margaret, alone and in much pain, went in search of something to ease her unquenchable thirst. She picked up the jug and began to drink the warm fat which must have made her very sick, but on his return, Francis found her much better and stronger. Margaret eventually recovered fully and lived to a ripe old age. Richard Furness, a neighbour and renowned in Eyam as a poet, wrote about the episode:

> But nature rallied, and her flame still burn'd –
> Sunk in the socket, glimmer'd and returned;
> The golden bowl and silver cord were sound;
> The cistern's wheel revolved its steady round;
> Fire- vital fire – evolved the living stream,
> And life's fine engine pump'd the purple stream.

By the end of April there had been seventy-three deaths, but in May there were only four deaths and two of those were from other causes, so the villagers had good reason to think the worst was over. They had to have a period of twenty-one days free from the infection before being sure, but sadly their hopes were short-lived.

There is no reason to think that life in Eyam, this truly remote, isolated village, didn't continue as it had for generations. The few approaches to the village were by rough, narrow tracks, so the village would have been independent and self-supporting. The lead miners and quarry workers would have continued to work, the shepherds would have tended their sheep and the farmers their cattle. Most households would have had a pig or cow and hens would have been plentiful. There was no way that anyone would starve; in fact, a lot of food stuff would go to waste. The eggs, butter and cheeses that would have been sold at market would be unwanted by the neighbouring towns and villages fearing that they were contaminated. Who would want infected milk or chickens?

Wet Withens, the prehistoric stone circle previously mentioned on Eyam Moor, was known to have been used like a marketplace during the period of the plague. With their mouths primed with tobacco, which they believed was a preservative, the people brought their provisions, laid them out, then stood at a distance from the people with whom they were going to deal. Bread was brought from Hazelford by a carter called Cooper, and another person is said to have brought victuals from Little Common, then a hamlet near Sheffield.

The buyers were not able to touch any of the articles before purchase, but when the agreement was finished, they would take the goods and deposit the money in the shallow waters of the stream that passes close by.

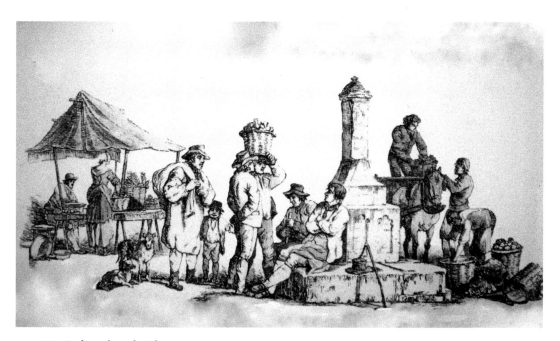

A typical rural marketplace.

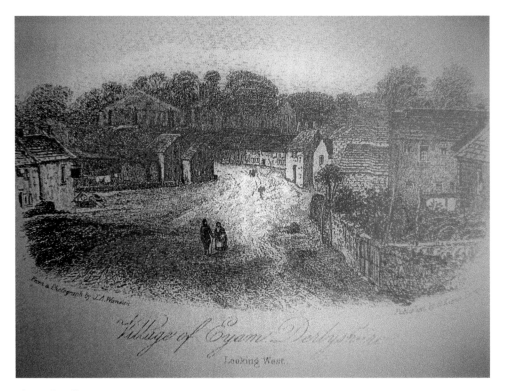

The early village street.

Carters kept the villagers supplied with essential commodities.

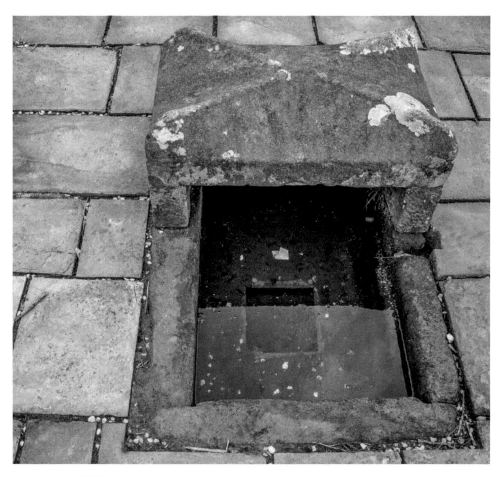

Mompesson's Well.

The villagers of Eyam fell into an uneasy routine. The previously mentioned Earl of Devonshire, of nearby Chatsworth House, had been reinstated at the Restoration of the Monarchy in 1660 and became steward of Tutbury and of the High Peak in 1661. It was in these roles that he arranged for supplies to be made available to the villagers, and for necessary supplies to be left at specific points on the fringe of the village.

Brick ovens were built at Bubnell, on the outskirts of Baslow, to provide the villagers of Eyam with fresh bread. The site of the kneading trough and bakehouse were marked on old maps. Once it was baked, the bread was taken by carters to the bottom of Eyam Dale where it was left and paid for by money sterilised in the brook.

As well as the two previously mentioned drop-off points, probably the most visited were Mompesson's Well on the North Road and the Boundary Stone between Eyam and Stoney Middleton. Mompesson's Well consists of a trough hewn out of stone with the addition of a stone canopy. Once the buyer had agreed to purchase a commodity, money would be placed in the shallow waters of the trough. In the top right-hand side of the magnificent stained-glass Plague Window in Eyam Church is an image of Mompesson's Well.

The boundary stone is a sandstone boulder pierced with a pattern of holes historians refer to as 'cup and ring' – (*see chapter* Eyam's Early History). Like so many such plague landmarks in other towns and parishes, it is sometimes called the Vinegar Stone or Penny Stone because vinegar was poured into the holes in the belief that this would sterilise the coins.

Designated drop-off points used during periods of plague are to be found in many parts of the country and are known as 'plague stones', 'leper stones' or 'penny stones'. It is not unlikely that Pennistone near Sheffield obtained its name from the existence of such a stone.

Did You Know
According to an account by White Watson, 'the brook near Stockingcote was called Monday Brook because during the plague year, the people of Eyam who would normally have gone to Bakewell's Monday market, 7 miles away were confined in the village. Monday brook formed a boundary into which they dropped their money in exchange for goods from the market, brought to them here.

Even so, nearby townships took stringent measures to intercept possible refugees and until recently a record survived at Sheffield concerning 'charges about keeping people from Fulwood Spring at the time of the plague at Eyam'.

A woman living in the area of Orchard Bank decided to go to Tideswell, one of the principle market towns of the Peak, frequented on market days by great numbers of people from the neighbouring villages. Although the people of Eyam were expected to stay within the boundaries of the village, she had every confidence that she could mingle with the crowds unrecognised, and having walked the 5 miles, the first obstacle was getting past the watch set up on the eastern entrance of Tideswell. It was their job to stop and question all who passed that way and to prevent anyone from Eyam entering the place on any business whatsoever.

'Whence comest though?' asked the watch authoritively.

'From Orchard Bank,' she replied.

'And where be that?' the watch asked.

'Why verily,' said the woman, ''tis in the land of the living.'

The watch, not being familiar with the area allowed her to pass, but she had scarcely reached the market when she was recognised.

'A woman from Eyam,' someone cried and the call resounded from all sides.

'The plague! The plague! A woman from Eyam.'

People started pelting her with stones, mud, sods and other missiles, forcing the poor woman to turn and run. The mob followed her until she was miles out Tideswell and she returned to Eyam, bruised and battered from her ordeal.

'A woman from Eyam' the people shouted.

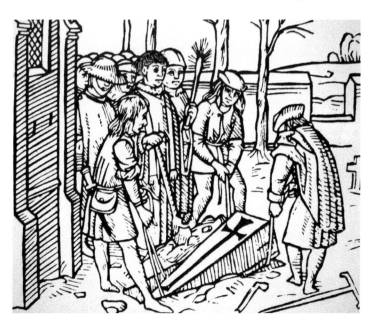

As more people died, a decision was made to stop church burials.

To avoid enclosed contact, the two clergymen decided that the church would be locked and the Revd William Mompesson, strong in his faith, preached God's word to his slowly diminishing congregation from a rock in the picturesque ravine once familiar as 'Cussy Dell', later Cucklet Church and now The Delph.

Did You Know
There's a strip of land in the Delph known as the Toothill which is claimed to be the site of an ancient Celtic altar or shrine consecrated by the Druids to the worship of Teutates, or Tuisti, the Celtic god of war whose name survives in our Tuesday. It's therefore very probable that 2,000 years before the plague, the ancient Britons worshipped in the Delph.

Death became so common that the two clergy made the decision that there would be no more organised churchyard burials and internment would take place without passing-bell or funeral rite. The church and churchyard were closed, and the dead were buried in shallow graves in makeshift cemeteries all around the village. Corpses were un-coffinned because the rapidly dwindling population had no heart for anything but marking the graves with wooden crosses or rude stones to identify where their dear ones lay.

Merrill House, home of the village herbalist.

Humphrey Merrill was the village herbalist at the time of the plague who would have relied upon a storehouse of natural products and recipes passed down through the generations. The inventiveness of the village herbalist was astonishing yet many of the recipes left more than a little to chance. Anne Merrill survived the plague but sadly Humphrey's remedies didn't prevent him dying from it in September 1666. The following are the kind of things Humphrey Merrill would have prescribed.

CURES FOR PLAGUE SICKNESS
Take barberries when they are ripe, steep them in warm water that the husks or outward skin may come off, then dry them that they may be beaten to a powder with a little salt, and when you find yourself somewhat discomposed, mix this powder with strong vinegar, about two drams in half a quarter of a pint and drink it up warm, and keep yourself warm also, that you may sweat upon it, but if you find yourself shivering with cold, you must take the powder in strong wine.

Take a great onion, hollow it, put in a fig, rue cut small and a dram of Venice treacle; put it close stuffed in wet paper, and roast it in the embers; apply it hot under the tumour.

A Most Excellent Drink Against The Plague
Take three gills of the best Malmsey; boil it till one pint be boiled away; put thereto long pepper, ginger and nutmeg beaten....let all these boil together. Put in one ounce of Mithridatum and two ounces of Venice Treacle and a quarter pint of aqua vitae. Take morning and evening one spoonful. There never was man, woman or child that this drink deceived.

The Best Pill Generally Under Heaven
Take the best yellow aloes, two ounces myrrh and saffron, of each one ounce; beat them together in a mortar a good while. Put in a little sweet wine then roll it up and of this make five pills. Take on a day next your heart, a scruple more and it will expulse the pestilence that day.

Plague Sickness
Take water of scabious, endive, rue and red roses, of each four ounces; white dittany, tormentile, white coral, gentian, and bole armoniack, with terra figillita; reduce those that are to be powdered separately. Infuse them in the water in a glass vessel and drink about an ounce at a time, pretty warm. Keep the body warm after it.

Plague Sickness
Take a viol or some other glass and fill it to the third part with Venice Treacle, the other third part with brandy or spirit of wine; mix these well together by shaking, and take morning and evening half an ounce in two ounces of mint, rue or balm water.

Contagious Distemper
This occurs as a very much approved remedy.
Take walnuts when the green husk is on them, and before the shell is
hardened underneath; put them when bruised into white wine eight days;
then with some balm, rue and tops of feverfew, and wormwood a little
bruised, put them into an alembick, and distil them; then when you drink
and ounce and a half of the water, which you may do morning, noon and
night, put in some perfumed confits, and stir them well about until
they are dissolved.

If there be a blotch appear, take a pigeon and pluck the feathers off her tail very bare,
and set her tail to the sore, and she will draw out the venom till she die. Apparently if no
pigeon was at hand, a chicken, frog or toad would do the same service of drawing out
the 'venom'.

Humphrey Merrill would have relied heavily upon advice given by 'The Plague Approved
Physician' that stated that to stay healthy, 'all should studiously avoid dancing, running,
leaping about, lechery and baths'. Another profound piece of information stated that the
plague 'never attempted the premises of tobacconists, tanners or shoemakers'. This is
why people stuffed tobacco in their mouths as a protective measure and plague doctors
wore leather.

Seventeenth-century Personal Protection

Personal protection for people on the front line of highly infectious/contagious diseases
is nothing new. The seventeenth-century plague doctors wore waxed leather ankle-length
overcoats, gloves, boots, and wide-brimmed leather hats to indicate their profession. To
protect them from airborne disease and bad smells known as miasma, which were thought
to be the principal cause of the disease before it was disproved by germ theory, the entire
face was covered with a bird-like mask. It had glass openings in the eyes and a curved,
bird-like beak that could hold sweet-smelling dried flowers like roses and carnations,
strong herbs like eucalyptus and peppermint, spices like camphor, or a vinegar-soaked
sponge. These plague doctors believed these things would counter the 'evil' smells of the
plague and prevent them from becoming infected. They also carried wooden canes to
point out areas needing attention and to examine patients without touching them. The
canes were also used to keep people away, to remove clothing from plague victims
without having to touch them, and to take a patient's pulse.

We have no evidence that Eyam had a plague doctor yet there is a related story
concerning the examination of a Bubnell carter who worked on the Chatsworth estate.
The Duke of Devonshire had instructed him to convey a load of timber to one of Eyam's
drop-off points but on the appointed day, the carter arrived at his destination to find
the place deserted and no one there to help him unload his wagon. In the steady drizzle
of rain, he unloaded it single handed and returned to Bubnell soaked to the skin and
chilled to the bone. When the unfortunate man started to cough and sneeze – the initial
symptoms of the plague – his terrified neighbours barricaded him in his house. One

The plague doctors' uniform.

neighbour even threatened to shoot him if he so much as tried to cross his threshold and rumours that the carter had brought the plague to Bubnell flew round the area. Eventually, this was brought to the attention of the Earl of Devonshire who arranged that his personal physician should examine the man to diagnose his complaint. Taking no risks, the patient was instructed to stand on the Bubnell side of the river Derwent while the doctor questioned him from the other side. After this strange examination was concluded, the doctor was confident that the carter had nothing more than a cold and he was allowed out of quarantine.

As time passed, the despairing population became listless. The labourer seldom went into the fields, the miners stayed out of the mines, and the shoemaker put aside his leather apron, hammer and last. Gardens and farmland became neglected and overgrown, and rabbits bred until the hillsides were almost overrun.

'The conditions of this place!' wrote the rector in one of his letters. 'My ears never heard such doleful lamentations, my nose never smelt such horrid smells, and my eyes never beheld such ghastly spectacles, the heart breaking sights, the tears, the silent grief, the hysterical woe!'

Not only did William and Catherine Mompesson and Thomas Stanley give comfort and administer to the spiritual needs of the people, they also performed the part of lawyer in the making of wills and numerous other matters. Thomas's brother (some say son), John Stanley, whose name occurs so often in documents during this time, was a Chesterfield attorney, but the handwriting and signatures of the Mompessons and Thomas Stanley are attached to many important deeds of conveyance.

People were dying.

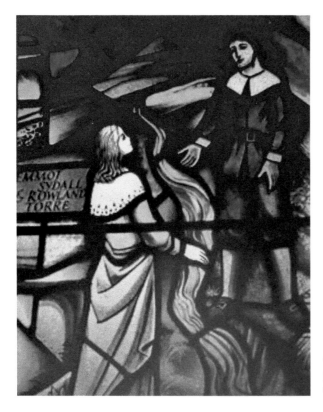

The meeting of Emmott and
Rowland depicted in the Plague
Window in Eyam Church.

Siddall Cottage opposite the church.

The Fated Love Story of Emmott and Rowland

Amongst the sad stories, we occasionally find one of hope, and here we have a typical love story. Emmott Syddall was a beautiful young woman who lived with her family in a thatched cottage in the heart of the village of Eyam. She was deeply in love with Rowland Torre, the son of the flour miller from the neighbouring village of Stoney Middleton, and like all young couples, they spent time together in simple pursuits just enjoying each other's company. But their brief spell of happiness was about to change forever with the villagers' imposed isolation. Emmott was detained in Eyam, forbidden to make any further contact with Rowland for the foreseeable future.

The Syddall family was soon plunged into mourning when Emmott's sister Sarah was the fifth plague victim. A month later on 11 October, Emmott's brother Richard was the thirteenth victim. On 14 October her father died and the following day her sister Ellen was the seventeenth victim.

Week after week Rowland waited patiently on the Eyam boundary to see Emmott amongst the congregation at the open-air church services held in The Delph. It was compulsory to keep a vast void of land between them but it was only through this kind of observation that Rowland was assured that Emmott was well.

On 22 October another sister, Elizabeth, died followed by sister Alice two days later, leaving only Emmott, her brother Joseph and mother Elizabeth Syddall who had lost her husband and five of her seven children in the first seven weeks of the plague. Then for almost six months the Syddall household was free of the plague and with renewed hopes, Emmott and Rowland made plans to marry during the following Wakes Week.

This may have been inspired by Emmott's mother Elizabeth marrying another Eyam resident, John Daniel, on 24 April 1666. It is also possible that a small wedding reception was held within the village and they unknowingly invited a plague victim who infected Emmott, because she died on 30 April, just five days after the wedding. This tragic love story of Emmott Syddall and Rowland Torre showing the young lovers meeting either side of a metaphorical stream is told in simple, graphic terms in the magnificent stained-glass Plague Window in Eyam Church.

Marshall Howe, Self-appointed Sexton and Gravedigger

In Tideswell Lane is a completely transformed cottage that during the plague years belonged to Marshall Howe. A sturdy lead miner, Howe had buried his own family but he had survived the plague, so could claim immunity, the principle on which vaccination is

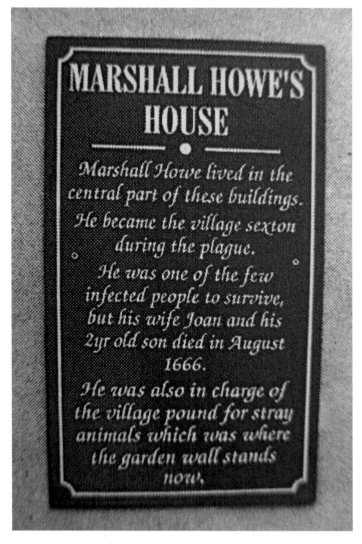

Marshall Howe plaque on his former house.

based. With so many dying, Howe turned his survival to good use by appointing himself the village sexton and gravedigger. This should have been a righteous act on Howe's part yet history has not been kind to Howe. He has been accused of being greedy and grasping while profiting from the distress of others. Apparently, he displayed a morbid audacity and impudence in relieving plague victims of their possessions in payment for his services, compensating himself for his work by rifling the homes of those he had buried. His actions did not go unnoticed, and the way he made claim to the deceased goods and chattels with such temerity created a sense of awe and astonishment amongst the people.

Did You Know
Marshall Howe, the unscrupulous, self-appointed sexton and gravedigger, was cheated of the spoils of one of the 'deceased' villagers named Unwin. When informed of his death, Howe hurriedly dug a shallow grave then ascended the stairs to the chamber where Unwin lay. He soon had the corpse on his back and was just descending the stairs when the supposedly dead man, in a kind of half-smothered rattle in his throat said, 'I want a posset!' Howe dropped the man and ran. Unwin got his posset and made a full recovery.

The 'corpse' revived.

Did You Know
Posset is a mulled ale and was drunk during the Eyam plague for its medicinal properties. Into the warm ale is added spices like ginger and nutmeg, a sweetener like syrup or honey, an egg and cream. Some people added a dash of rum or other spirit too. Posset was a favourite Derbyshire drink consumed on Christmas eve or special celebratory occasions, particularly weddings when it was given as an aphrodisiac to newlyweds. At such times, it was also customary to add a slice of spiced bread, toasted until it was a uniform straw colour, then broken into the posset jug and soaked with the liquid. One of the first accounts of this custom can be found in Shakespeare's play *The Merry Wives of Windsor* when Falstaff demands 'Go getch me a quart of sack and put toast in't.' From this comes the saying 'to drink a toast'.

The summer of 1666 saw many deaths, and on 25 August, exactly a year after the cloth had arrived in Eyam, Catherine Mompesson, the rector's wife who had done so much for the despairing villagers, died. Although the churchyard was closed for burials during the plague, an exception was made for her. Catherine Mompesson's table tomb was designed by her husband with its inscription 'Beware ye know not the hour' in Latin. A visitor to the grave on the last Sunday in August, which has become known as Plague Sunday, will find a wreath of red flowers upon it. It's a long-established custom that the wife of the incumbent of the day places them there because not only is Plague Sunday close to the anniversary of the outbreak of plague in 1665, a year later on 25 August Catherine Mompesson was buried.

Then after a very long fifteen months, it was all over. On 1 November 1666, farmworker Abraham Marten was the last of 260 residents of Eyam to die. The Martens had lost eleven family members and were just one of the seventy-six families who had lost so much. Slowly relatives and friends returned to the village to find no smoke ascending from the ivy-adorned chimneys, and a noiseless gloom pervading the lonely street.

Catherine Mompesson's tomb.

'Catherina, vxor Gvlielmi Mompesson hvjvs Ecclesiæ Rect. filia Radvlphi Carr, nvper de Cocken in comitatv Dvnelmensis, armigeri. Sepvlta Vicessimo Qvinto die mensis Avgti, Ano. Dni., 1666 ;'

on other parts of the tomb are, 'CAVE NESCITIS NOVAM,' and 'MIHI LVCRVM.'

The writing on the tomb.

But yet no Sabbath sound
came from the village; no rejoicing bells
were heard, no groups of strolling youths were found,
nor loitering lovers on the distant fells.
No laugh, no shout of infancy, which tells
where radiant health and happiness repair
But silence, such as with the lifeless dwells
fell on his shuddering heart and fixed him there
Frozen with dreams of death and bodings of despair.

William and Mary Howitt

Did You Know
Andrew Merrill, who lived at Hollins House, survived the plague by going to the summit of Sir William Hill Road and building a crude hut in which he lived with his pet cockerel until the plague was over. Apparently, one morning after strutting around for a while, the cock flapped his wings and flew back to its former home. Merrill pondered for a day or two over the meaning of his companion's abrupt departure, then decided that just as Noah had sent the dove to see whether the waters had subsided after the flood, the bird's departure could signify the end of the plague. Andrew Merrill collected up his belongings and returned to Eyam to find the cockerel on his old perch and the plague had abated.

The plague was over, safely in the past, and for Samuel Pepys, London had already returned to normal when he wrote in October 1666 that he was off to the playhouse to see 'the first play I have seen since before the great plague'.

The village street.

In Eyam in those post-plague days, Marshall Howe, the self-appointed gravedigger and sexton, would entertain the company by boasting in the village alehouse about his illicit plunder adding that he had 'pinners and napkins enough to kindle his pipe while he lived'.

It was written that after the plague, the Revd William Mompesson personally supervised the destruction of all materials calculated to conceal germs before leaving Eyam in 1669 to take over the living at Eakring, Nottinghamshire, a parish in the Southwell district. But such was the reputation of the 'plague village' that he was forced to live in a hut in Rufford Park until the residents' fears had abated. In 1670 he remarried, his second wife being a widow, Elizabeth Newby, a relative of his patron, Sir George Saville. William Mompesson spent no more than five years of his long life in Eyam before moving to Eakring where he was an administrator and reformer, and an influential member of the Chapter of Southwell Minster. Through the patronage of Sir George Saville, Mompesson eventually became Prebendary of Southwell although he declined the opportunity to be Dean of Lincoln Cathedral. He died on 7 March 1709 and is commemorated with a simple memorial in Eakring churchyard. Hanging in Southwell Minster is an original oil painting of the Revd William Mompesson, a copy of which is in the choir vestry of Eyam Church.

The Revd Thomas Stanley remained in the village and died there in 1670, but although he is buried in the churchyard, the location is now unknown. There is a monument to him adjoining the priest's door, a stone by the chancel wall with the words 'He stood between the Living and The Dead and the plague was stayed.'

Did You Know
The 3rd Earl of Devonshire of Chatsworth House had arranged for the villagers of Eyam to obtain supplies, but the title is now extinct. His son, William Cavendish (1640–1707), succeeded his father as the 4th Earl of Devonshire and gained notoriety as one of the Immortal Seven group. They invited William III, Prince of Orange to depose James II of England as monarch during the Glorious Revolution, and the Earl of Devonshire was rewarded for his efforts with the elevation to Duke of Devonshire in 1694.

Above: All contaminated goods were burnt.

Right: Reverend Mompesson.

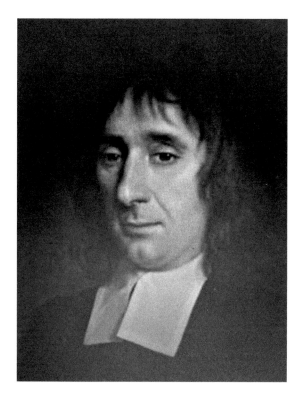

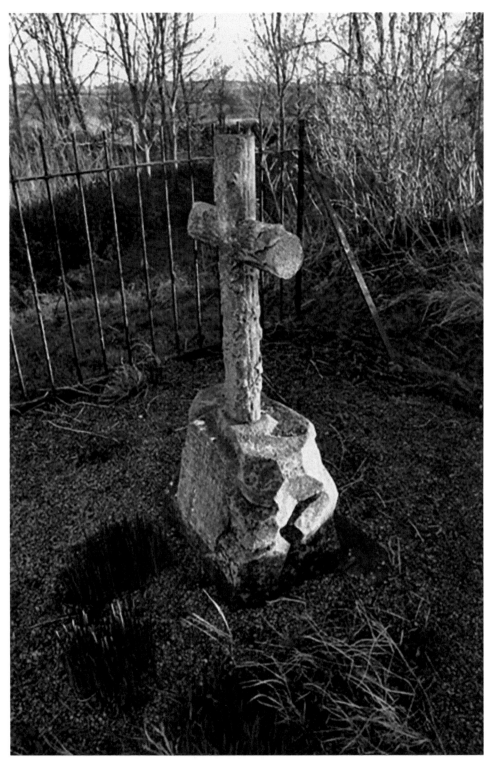

Reverend Mompesson's simple grave at Eakring.

As previously mentioned, we are told that the Revd William Mompesson ordered furniture, clothing, bedding and all materials calculated to conceal germs to be burnt on huge bonfires, yet there is a popular belief that the cupboard in the north aisle of the church was made from the plague-infested clothes box. Until recently when it was moved to the museum, the chair believed to be the one used by Mompesson while in Eyam was also in the church. Made of oak and carved with the inscription 'Mom 1662 Eyam', the panel in the back is carved with a crude representation of the Virgin and Child. It was rescued from a Liverpool antique shop by the Revd Canon E. Hacking, a former rector, and presented to the church. At Cheltenham, a carved settle bearing the names of William and Catherine Mompesson was offered to the village, but was not purchased. A striped glass, formerly displayed in the museum of Poole's cavern, Buxton, purported to be a personal possession of Mompesson. Adding an extra flourish, it was said to have held vinegar in which coins were washed during the plague, but along with other exhibits, the glass was stolen during a raid.

Chair used by Mompesson.

The 2009 well dressing at town end dedicated to Anna Seward – to mark the 200th anniversary of her death.

One hundred years after the plague, Anna Seward, the vicar's daughter, questioned the burning of all material calculated to conceal germs. She suggested that the word could have been 'buried' rather than 'burned'. She came to this assumption when in 1757, five cottagers were digging in the heathy moorland above Eyam which was used as a graveyard during the plague.

According to Miss Seward, they came across something which had the appearance of having once been 'linen' and conscious of their situation, hastily buried it again. Within a few days, all five cottagers sickened and three died. As more people died, the people of Eyam were terrified that a new epidemic of the deadly plague had been awakened from the dust in which it had slumbered for ninety-one years. Miss Seward's information was obtained from a Dr Holland who put the number of dead at seventy, but according to William Wood, Miss Seward was misinformed. There was no corroborative evidence to support this claim, and the mortality rate of that year was normal.

Did You Know
Anna Seward and subsequent writers have questioned reports of what happened. It has long been believed that corpses were wrapped in linen, and all contaminated items were burnt. However, could the word 'burned' have been 'buried' and could the word 'linen' have been 'lime'? Lime was used in the interment of un-coffined corpses.

4. After the Plague

There is evidence that the early gravestones that did exist have been removed over the centuries and used for alternative purposes. The rough slabs were useful to pave cottage floors and barns. Many were laid as paths and worn by so many feet that any inscriptions or means of identification are now impossible. Often these stones were sacrilegiously broken up for other purposes, but several gravestones have survived the wear and tear, violation and vandalism of three and a half centuries, and we will track them down.

The cottage that is now The Eyam Tea Rooms in The Square was the home of Thomas and Alice Rowland and their family during the plague. Hannah, aged fifteen, died on 5 November 1665; Mary, her thirteen-year-old sister, died on 1 December; Abel, their ten-year-old brother, died on 15 January; and their father, Thomas, died here on 14 February 1666. Alice and one son, Francis, survived the plague. Although we can't locate the others, Abel's gravestone can be seen in the churchyard against the east wall of the south aisle near the sundial, placed there after being found in use as a flagstone on the floor of one of the cottages.

Eyam tea rooms.

Did You Know
Abel Rowland died on 15 January 1666 but the stone is marked 1665. This is not a stonemason's error; prior to 1752, New Year's Day fell on 25 March, so January 1665 followed December 1665.

During the plague, what is now the Old Post Office was the home of the Wragg family who were early victims of the plague. In more recent years, it served as a post office but when it was being altered and sewerage excavations were being made in 1963, the gravestone of Alice Wragg was found under the floor. Although home internment was not unknown in the past, it's more likely that for 300 years this stone served as a paving slab in the parlour.

Humphrey Merrill, herbalist, is buried in a field near his former seventeenth-century home, now known as Merrill House. The place is marked by a table tomb.

At the back of the Miners Arms, a character building built around twenty years before the deadly plague struck the village is an area known as The Croft which became an unconsecrated graveyard. This plot was just one that was used for internment for many families during the plague. Others were buried in land contiguous to their homes. Unlike in many towns where victims were buried in communal plague pits, there is no evidence

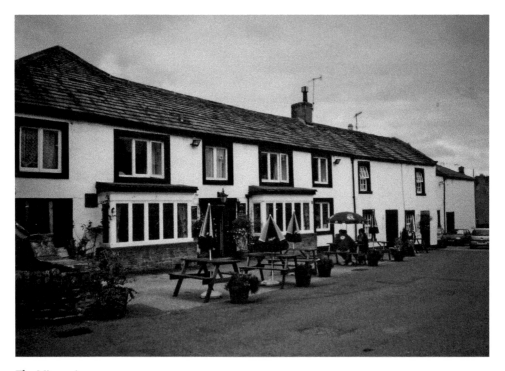

The Miners Arms.

Above and right: Amusements during Wakes Week are held on The Croft, which became an unconsecrated graveyard during the plague.

The Peak Pantry.

of this in Eyam. In more recent years, The Croft became the site of the amusement caterers with their roundabouts, swing boats and coconut shies transforming the old burial site into the annual fairground held during Wakes Week.

Also in The Square is Peak Pantry tea Shop, known as Torre House because in the plague years it was the residence of the Torre family. John Torre died here on 29 July 1666. His son Godfrey, aged eight months, died on 3 August 1666, but his wife Joan survived the plague.

In a field on the left of Water Lane below Barkers Piece are the 1666 graves of two plague victims, sisters Margaret and Alice Taylor. These two horizontal gravestones lay unmolested on this sunny hillside near the long-vanished home of the sisters, but in later years the stones have been turfed over.

The former village poor-house where the paupers of the parish suffered pain, misery and humiliation in their declining years is on Edge Road. William Wood, the Eyam chronicler, referred to several plague memorial stones recording the deaths of people named Whiteley, behind and to the west end of these buildings, but they are no longer there.

The natural hollow known as the Delph of Delf used as an open–air church during the plague was also used for burial purposes according to William Wood, who referred to two or three headstones that once existed in the Delph, to the memory of the Wraggs, but they are now lost without trace.

The Lydgate Graves

Although now a narrow lane by the side of the telephone and post boxes, Lydgate used to be the old main road from Eyam into the village of Stoney Middleton before the road was cut through Eyam Dale in the nineteenth century. At the entrance to Lydgate is the pinfold where stray animals were kept until their owners paid a release fee. Lyd or Lid is a Saxon word which means to cover or protect. We are all familiar with lids covering

containers to protect the contents, but this scenario is different. Here was a strong gate at which 'watch and ward' was kept every night between 9 p.m. and 6 a.m. to protect the villagers. Every able-bodied male householder in the village was officially bound to take a turn at this gate to question anyone entering the village. Each watchman had a large wooden halbert or watch-bill for protection, and when he came off duty in the morning, he took the watch-bill and reared it against the door of the next watcher.

Did You Know
The custom of Watch and Ward was practiced into the eighteenth century with Eyam being one of the last villages to retain this very ancient ritual.

If you walk along Lydgate, on your right is Rose and Fossil Cottage. During the time of the plague, this was the home of John and Francis Wood and ironically, 200 years later it became the home of William Wood, Eyam historian and village chronicler, unrelated to the previous occupants.

A few yards further, we reach Lydgate Cottage by the side of which are the 1666 plague graves of Thomas and Mary Darby in a small walled enclosure which was once part of the Parson's field – a piece of Glebe land now occupied by a small housing estate. These are known as the Lydgate Graves. George Darby died on 4 July 1666 and his daughter Mary, aged twenty, died on 4 September. Tradition says that Mary Darby was seized by the plague as she gathered flowers for her father's grave and died the following day, but George's wife survived and died eight years later in 1674.

One hundred yards further, on the right of Lydgate is The Rock, the former home of Clarence Daniel (1911–87), the Eyam antiquarian and lifelong resident of Eyam whose ancestors survived the plague. Clarence published the first of his books about Eyam when

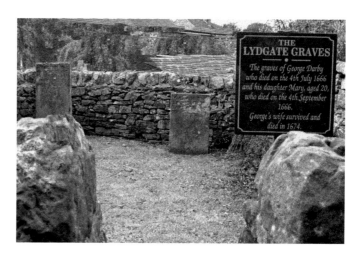

The Lydgate graves of Thomas and Mary Darby.

he was twenty-one, illustrating it with his own drawings. From early youth, he avidly collected everything associated with his native village and in 1976 achieved his dearest ambition of opening a small private museum at The Rock, to display the treasures which he had accumulated throughout his life. After his death in 1987, his wife Cecily donated his collection to the Eyam Village Society, in the hope, now realised that it would inspire the foundation of a museum.

Did You Know
The Eyam Museum opened in 1994. Note the weathervane on the roof with the black rat, the cause of that dreadful plague.

The Riley Graves

Riley is an upland area on the outskirts of Eyam. The name comes from Rois Leys, which means King's field. There have been various references to the existence of several large stones which formed a prehistoric circle near Riley, and when taking up the foundations of an old wall here in the late eighteenth century, Robert Broomhead of Eyam broke an ancient burial urn. These may seem like isolated finds but many ancient tumuli and their contents, mainly cinerary urns, have been found at various times around Eyam. Perhaps there is still more to find.

Although around ¼ of a mile outside the village, the Riley graves are said to be the most visited of Eyam's plague monuments, possibly because of the poignant tale attached. Although nothing now remains, around 50 yards from the enclosed cemetery that is now more widely known as the Riley graves is an ash tree standing in a north-east direction of the stones. A few yards south of this tree was the home of the Hancock family consisting of John Hancock, his wife and six children.

Around 250 yards north-west of the Hancock home was the home of the Talbot family, which consisted of Richard Talbot, his wife Catherine, three sons (although one had left home) and three daughters. The present Riley Farmhouse is built on the site of the Talbot house. Richard Talbot was a blacksmith and had a smithy adjoining the house, and close to the road because in those early days the road from Manchester to Sheffield passed close by this property.

In mid-1666, the pestilence had raged ten months in Eyam when on 5 July, the plague arrived at Riley with the death of Bridget and Mary Talbot. Two days later, Ann, the third daughter, died. The mother, Catherine, died on 18 July followed by son Robert on the 24th. The following day the father, Richard, died leaving only one son, who died on 30 July. The entire family of seven had died within nineteen days. They were all buried hurriedly without any form of religious ceremony, interred together close by their home and in the orchard of the present Riley House. The monument with the inscription 'Richard Talbot, Catherine his wife, two sons and three daughters, buried July 1666' is almost erased.

Above and below: The road leading to Riley.

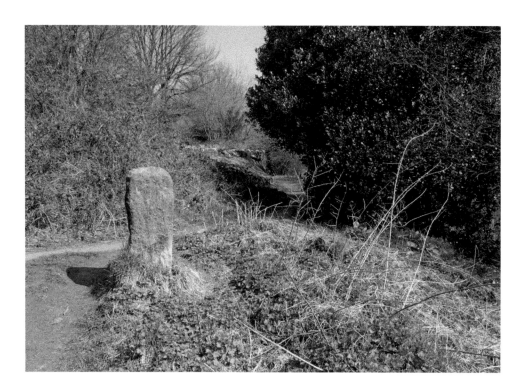

The last of the Talbots was probably buried by their neighbours the Hancocks, and thus the plague passed to them. On 3 August, only three days later, two of the children, John and Elizabeth Hancock, both died and were buried a short distance from their home. On 6 August son Oner died, followed by husband John and son William – three deaths in one day. Alice died on 9 August and Ann on the 10th. According to tradition, Mrs Hancock buried them all single handedly, then left to live with her only surviving son who was an apprentice in Sheffield. She was the only survivor of the little community at Riley. It was this son who erected the tomb and stones in memory of his family. But the site of the graves was on the common or moor, and when this was later enclosed, in order to preserve what would have been forgotten graves, Thomas Birds, an Eyam antiquary, had the stones removed and the inscriptions incised more deeply. They were then placed closer together high on the hillside above Eyam and surrounded by a protective, heart-shaped stone wall.

The headstone of John Hancock is possibly in its original place and bears the inscription:

> Remember man, As though goest by,
> As though art now, even so was I
> As I do now, so must thou lye
> Remember Man, that thou shalt die

On the six headstones that have been brought together the inscriptions are :

> Elizabeth Hancock, Buried Aug 3 1666
> John Hancock, Buried Aug 3 1666
> Oner Hancock, Buried Aug 7 1666
> William Hancock, Buried Aug 7 1666
> Alice Hancock, Buried Aug 9 1666
> Ann Hancock, Buried Aug 10 1666

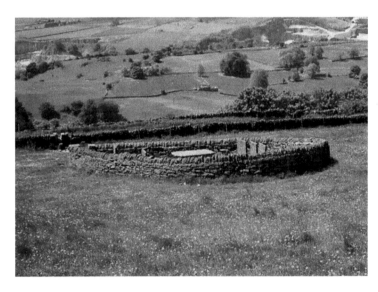

The Hancock graves at Riley.

A pastoral scene of the Riley graves.

The Bretton Graves

Even though the isolated hamlet of Bretton is 1½ miles from Eyam, it was still affected by the plague. At one of the old Bretton farmsteads that's now a youth hostel, you'll find five sunken stones lying in careless confusion among the unkempt grass to perpetuate the sad event. One bears the initials P.M indicating the grave of Peter Mortin, the first plague victim who died at Bretton on 4 February 1666. Six months later on the last day of July, Ann Mortin died. Sarah Blackwell died on 13 August, Peter Hall on 23 August, and Ann Townsend on 22 September.

In the same area was Shepherd Flat Farm, the home of Matthew Mortin and his family who were probably related to the previously mentioned family. At the rear of the house are farm buildings, fragments of which appear to have survived from the seventeenth century because built into a corner of one of these can be seen two stones roughly carved with several letters, one of which has been obliterated by a smudge of cement. These stones have been recognised as being lettered by Matthew Mortin as a memorial to his wife and children who died in the plague. At that time, there were two houses in this area; the Mortins lived at what is now Shepherd Flat Farm and at a neighbouring cottage lived a widow named Lydia Kempe with her four children. As a result of these children playing with children from Eyam, the plague was brought to this lonely spot where on 13 July Robert Kempe died. His sister Elizabeth died on 11 August, followed by his brothers Thomas and Michael on the 12th and 15th. A week later Lydia Kempe was buried with her children.

The Mortins must have been horrified because Mrs Mortin was in the advance stages of pregnancy and as the time of birth drew near, Mr Matthew Mortin went down into Eyam to obtain the services of the village midwife. Despite his ardent appeals, the woman adamantly refused her services. Returning to his home, Matthew Morton found his eldest son Robert, aged three, screaming in agony; he had contracted the plague. Within a few days Robert and his two-year-old sister Sarah were dead, closely followed by Mrs Mortin and her newborn son. Matthew buried his little family and recorded this sad event on the gable end of the shippen, once the old house. He carved the initials of his older children and a small 's' for the tiny son who died unbaptised.

Plague Sunday, Wakes and Well Dressings

It's understandable that a village that had lost so many of its residents should never forget, and the annual Wake begins with a solemn service to mark the religious aspect, and a service in The Delph to recall the heroism of those who died in the plague. It was the Revd Thomas Seward who on the last Sunday in August 1765, to mark the centenary of the outbreak of the plague, stood where Mompesson had stood in The Delph and preached a sermon as he had done. There was also a service to mark the bicentenary, and the service in its present form has been conducted every year since 1910.

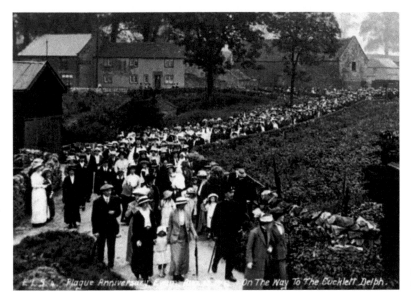

The popularity of the annual plague service is shown in this early photo.

Village women in seventeenth-century dress attend the annual plague service.

The day has become known as Plague Sunday, and this now marks the beginning of Eyam's well-dressing week in which the village wells are all blessed and dressed in a custom so typical of the Peak District of Derbyshire.

In Eyam, this custom was revived in 1951 as a Festival of Britain celebration when old ammunition crates were converted into screens. That first design showed the village church and a tableau depicting Adam and Eve. The masonry of the church was largely made of broad beans, while village gardens provided the dearth of flowers to create the garden that sheltered the discreetly painted figures of Adam and Eve.

Did You Know
One year, a bath full of clay from Ladywash Lead Mine was being soaked in preparation for making the annual Eyam well-dressings, and quite by chance Clarence Daniel, Eyam historian, picked up a knob of the clay to discover that embedded in it was a small wooden pipe known as an acorn pipe because that is what the bowl resembles. Such pipes were common a century or two ago, and superstitious miners often left votive offerings like this pipe in the underground workings of the mine for the T'Owd man, a strange figment of Peak District lead mining lore. Lead miners looked on T'Owd Man as the collective spirit of the mine and their own predecessors, and he was offered great respect. T'Owd man's domain was the dark and dangerous subterranean world of the miners and abandoned workings in particular. The acorn pipe is now on display at the Eyam museum.

Every passing year had added to the experience and inventiveness of the well dressers who create mosaic masterpieces from mosses, shells, petals, pebbles and other materials pressed into a background of softened clay. When they are erected these spectacular well dressings have the luminosity of stained-glass windows, the colours glowing in their concentrated splendour, and for a week, each floral shrine is the focus of attention for visitors and villagers alike. As the days pass, the clay becomes dehydrated giving the appearance of an old oil painting with its cracked and faded canvas, then on the following Saturday the village becomes a charisma of colour and sound as a procession of decorated floats, festival queens and marching bands parade through the village streets decorated with fluttering flags and garlands.

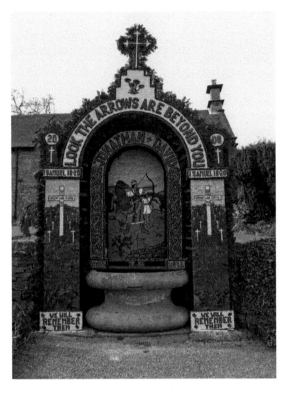

Left: Well dressings.

Below: The village parade.

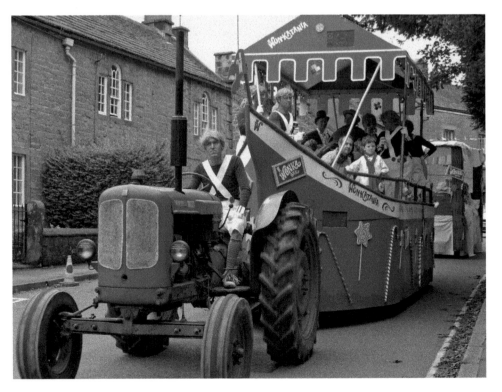

5. Eyam Then and Now

As a village, Eyam developed slowly, gaining a unique character and independence.

The irregular streets are fringed with homely cottages and knots of houses devoid of architectural discipline, because when necessity arose or circumstances permitted, the occupants simply changed or added to their cottages unfettered by restrictions imposed by rural authorities. At one time, all the cottages would have been thatched but they've been re-roofed with slate from the now redundant slate-pits near Eyam. Over the years the labourers' hovels would have been replaced by unsanitary cottages which in turn were swept away and replaced by clearance orders, but fortunately Eyam has many period cottages and historical artefacts dating back centuries and dotted amongst them are several dignified buildings making a very pleasing street scene.

The Square is in the heart of Eyam. It was here that the cruel amusement of bull-baiting took place until it was banned in the late eighteenth century. Bulls were tethered while being baited by vicious dogs but slowly the cruel sport disappeared and the old bull rings were removed. Eyam's useless reminder of such a barbarous sport lay buried for forty years until it was excavated in 1911, then concealed beneath an iron inspection cover. With repeated layers of road-repair material, the level of the road had been gradually raised

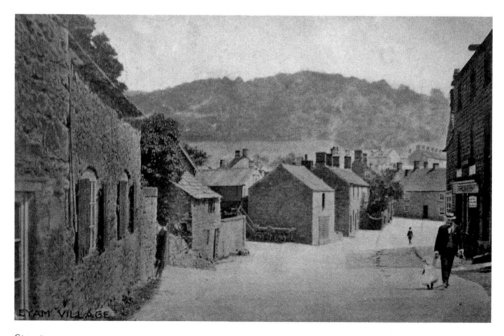

Street scene.

and the edges and hinges of the cover were sealed with a crust of tarmacadam. By this time, it had become a thing of historical interest, so to make it accessible to the public, the bull ring was raised to road level, and the key necessary to raise the lid was placed in the custody of Mr J. M. Rylands, a veterinary surgeon who lived opposite the ring in The Forester's House, one of the former seven inns in the village and known then as The Foresters Arms. When improvement work was undertaken in 1986, the ring attached to a heavy chunk of stone was lifted and moved to its present site outside the Peak Pantry tea shop on the northern side of The Square, so Eyam, like its Foolow neighbour, kept its bull ring, two of the four (another is at Snitterton near Matlock) still in existence in Derbyshire.

Throughout the village there are many water troughs forming a system that was established in 1558. It is said to be one of the first public water supplies in the country and provided water for domestic as well as agricultural purposes for over 360 years. Within living memory, the tap in The Square supplied 'hard' water for drinking while a trough opposite supplied 'soft' water for washing purposes. There was also a cottage that had been the village's communal 'mangle house'. Housewives would take their clothes to be mangled on a cumbersome machine operated by a series of wooden rollers. When mangles became available to most householders, the redundant village mangle was dismantled and transferred to the joiner's shop across the way where it was converted into a bench.

Standing on rising ground at the north-west of the village is the ruined Bradshaw Hall on the same site and incorporating part of the earlier Stafford Hall. There is every possibility that Bradshaw Hall was partially destroyed during the Civil War because sadly it never appeared to be the Bradshaw's family home after that. For a period of time, the reduced Bradshaw Hall was occupied by other families then converted into a cotton mill, when it was seriously damaged by fire. According to *The History and Antiquities of Eyam*, by the early nineteenth century it was greatly dilapidated and used as a barn. In 1961, there was subsidence of the south-west corner of the building, and in 1962, the corner fell away. It was necessary to demolish all the unsafe stonework leaving only the northern corner, and in 2006 an excavation revealed fragments of seventeenth- and eighteenth-century pottery, bone and glass that are now on display in the museum.

According to some reports, the fabric of the building of Bradshaw Hall was used by Thomas Wright to build Eyam Hall around 1677. At the core of Eyam Hall is a Tudor mansion that was originally the residence of the Brays of Eyam. It was purchased by Thomas Wright around the middle of the seventeenth century. A new front was erected and other alterations made around 1677 using materials from Bradshaw Hall. Some of the interior wainscoting has the initials F. B. and J. B., with the date 1594 (or possibly 6) and an inverted stone on the outside with the initials M. B. This leaves us with the question, are these initials connected with the Bray or the Bradshaw families? There is a poem written on one of the panes of glass and on another someone has inscribed the crest and arms of the Wright family, an ownership that has stretched unbroken for over 300 years. Eyam Hall opened its doors to the public in 1992, reflecting in its ambience the fact that this charming family-owned manor house has been the much-loved home of the Wright family for many years. It is one of the most welcoming houses in Derbyshire, and a guided tour is highly recommended.

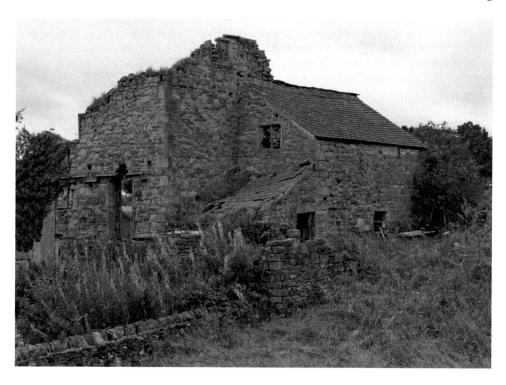

Above and right: Bradshaw Hall.

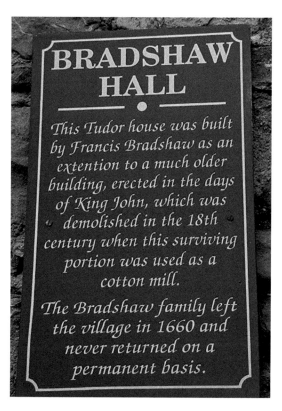

BRADSHAW HALL

This Tudor house was built by Francis Bradshaw as an extention to a much older building, erected in the days of King John, which was demolished in the 18th century when this surviving portion was used as a cotton mill.

The Bradshaw family left the village in 1660 and never returned on a permanent basis.

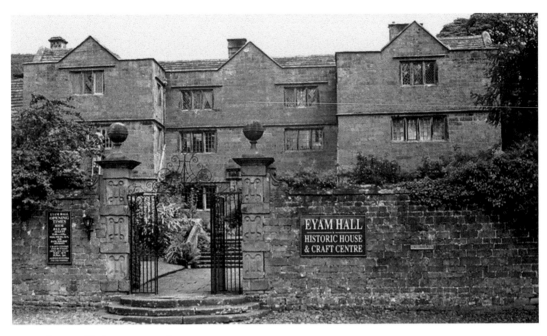

Above and below: Eyam Hall.

The courtyard of Eyam Hall.

The old laundry.

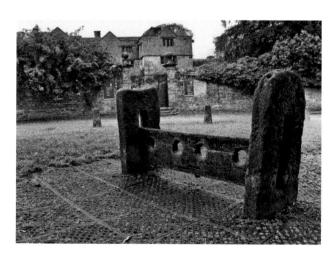

Village stocks with Eyam
Hall behind.

Almost opposite Eyam Hall in the centre of the green is the village stocks, restored in 1951 to mark the Festival of Britain. Stocks were not introduced into English law until 1351 but by a statute of 1405, any village without a set of stocks could be downgraded to a hamlet. Not surprisingly, few survive but this is a fine example. It obviously didn't cut out all crime because by 1808 crime had become such a problem that the Eyam and Stoney Middleton Society for the Prosecution of Felons was set up to keep law and order, a job which was handed over to the modern police force in 1857.

Did You Know
Those who refused to obey the law could be put in the stocks for all manner of petty crimes too numerous to mention, and in the seventeenth century, a further amendment was added to the already existing list of crimes punishable by a period in the stocks – 'Any person convicted of drunkenness should be fined 5s or spend six hours in the stocks.'

On one side of the plague cottages is a small green field that used to be the site of the village duck pond which was known as the Eaver. Some say it's not a duck pond, but a ducking pond where scolds and witches were ducked as a form of punishment. The accused was strapped to a chair on the end of a plank and lowered into the pond. The amount of dips and the extent of time in the water depended upon the severity of the crime. It's no longer a pond and in the centre of this area is the roasting spit used as a sheep roast at the village carnival time. The building behind the spit is a pigeon house in Eyam Hall gardens. This rare example dates from an age before refrigeration when fresh meat in winter was in very short supply. Fresh pigeon was a welcome addition to a diet of salted or dried meat.

The Church

On the other side of the plague cottages is the church. A wander round the church is highly recommended as there are some very interesting things to look out for. Thomas Stanley and William Mompesson would have spoken from the Jacobean pulpit. The plague register showing Eyam's death toll during the plague is on display in its glass case, and not to be missed is the magnificent Plague Window. There's also a brass tablet in memory of Stanley and the two Mompessons. Some years ago, the Staffords pew from that earlier church was made into the screen which now encloses the belfry. Hanging in the vestry is a bronze lamp of Tudor origin, which if genuinely connected with the church should hang in the north aisle as it is claimed to be the original legendary lamp of St Helen.

The church was altered to the design of the famous architect John Edmund Street, whose work included the Law Courts in London, to mark the bicentennial of the Eyam plague commemorated in 1866. Work over the next twenty years included doubling the width of the north aisle, a new porch, renovation of the south aisle, new vestries, removal

of the galleries, and replacement of the chancel roof. In 1988, a new stained-glass window depicting the plague was installed in the north aisle and a small extension added to the north of the tower, with more restoration work being carried out in 1997.

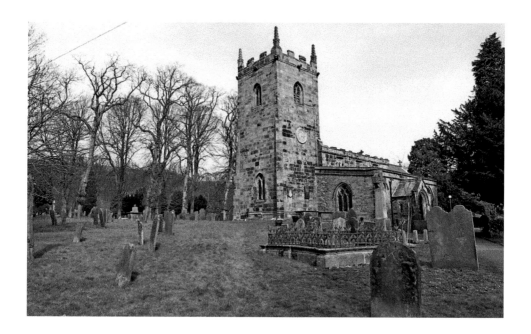

Above: Eyam Church.

Right: The plague register.

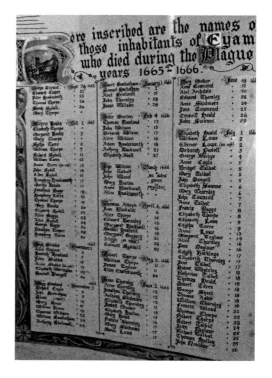

Mechanics' Institute

Opposite the churchyard is the Mechanics' Institute where many of the early villagers learnt to read and write. The first Mechanics' Institutes were established in 1821 and funded by local industrialists to provide education in technical subjects for the benefit of their employees. They were also used as libraries for the working class, providing an alternative to gambling and drinking. In 1824, a library was established in Eyam but it wasn't until 1857 that three cottages in Church Street were purchased to provide a Library, Reading Room, and Institution for the promotion of Science and Literature and Diffusion of Useful Knowledge. The cottages were demolished and the current Mechanics' Institute building erected in 1860. With the establishment of state education and public libraries, the educational role of the building has changed over the years but has continued to play an important part in village life as the Village Hall.

Furness House

Furness House, previously known as Olde House, dates from 1615, but the change of name was because it was the birthplace, on 2 August 1791, of Richard Furness (1791–1857). He was renowned in Eyam as a poet who wrote thirty carols and was called the Poet Laureate of the Peak. The house is still in family hands.

Eyam Dale House

A small country house that is now a care home is Eyam Dale House. Until recently it was the executive headquarters of Glebe Mines Ltd and before that, the home of Thomas Bird, an Eyam antiquary who entertained many important guests there including royalty. Prior to this, it was owned and occupied by Thomas Fenton, a surgeon who inherited much of the property of his maternal grandfather, Philip Weldon.

Surgery was advancing, but the need for human bodies to experiment on was never equal to the demand. Religious beliefs and common superstition made it unthinkable as well as unlawful to tamper with a dead person's remains, so in order to expand the surgeon's knowledge the only human bodies available for examination were those of executed criminals. Even so, the supply did not satisfy demand, so a new rather unsavoury practice known as bodysnatching became quite widespread. Lonely churchyards were robbed of fresh corpses to procure bodies for experimental purposes, and the grateful surgeons asked no questions. Thomas Fenton was one such surgeon.

Many villains turned bodysnatching into a lucrative business, but it was necessary to take only the naked body. In the eyes of the law, there was no property in a dead body, so it could not be stolen, but if a ring or the shroud was taken with the body, the thieves could be severely punished. In order to avoid this, the resurrectionists would dig up a body, drag it from the grave, strip it of the shroud and any other possessions, bundle it in a sack and trundle it away. If time permitted, the shroud would be returned to the coffin which would then be covered again to conceal their clandestine activities.

Although the subject is not pleasant, the practice of bodysnatching has left us with some amusing stories. One night, two rascals arrived on the doorstep of the local surgeon with a body trussed in a sack.

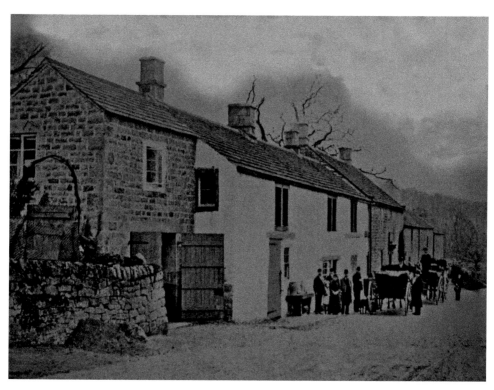

Above and below: The Chequers, on a lonely stretch of road above Eyam, was notorious as a spot for supplying bodies.

'Take it down the cellar,' the surgeon said and then paid the men who headed speedily back to the local tavern. The surgeon went down to examine his purchase and found that the body was not dead, just dead drunk. The following night, 'the body' shared the fee with his pals in yet another drunken spree.

Eyam Rectors

The list of Eyam rectors dates back to 1250, so The Rectory has been home to some very interesting people apart from the Revd Thomas Stanley and Revd William Mompesson, rectors during the period of the plague. A rather more colourful vicar was the Revd Joseph Hunt who was appointed the rector of Eyam on 21 March 1684.

The Revd Hunt hadn't been in Eyam long when Matthew Fearns, one of his parishioners and landlord of the Miners Arms, asked him to baptise his newborn child. After the ceremony, the congregation and the rector were invited to participate in the custom of 'whetting the baby's head' at the Miners Arms. In the merrymaking that followed, Joseph got a little drunk and began to make advances to the landlord's eighteen-year-old daughter, Ann.

Egged on by the drunken revellers, Joseph produced a Book of Common Prayer and went through the Solemnisation of Holy Matrimony ceremony with Ann. Amid a lot of hilarity, each made the customary vows and promises in a mock wedding ceremony conducted by one of the other guests and witnessed by the whole gathering.

News of this didn't take long to reach the Bishop of Derby, who was furious and adamant that Joseph should marry Ann in the proper manner, so in order to right the wrongs and confirm the union legally, they were married in church on 4 September 1684. As their first child was born two months later, it would appear that their mock marriage was consummated too.

But this news did not please one particular Derby lady who had been under the impression that once Joseph had settled in his new parish, she would become the new Mrs Hunt. Research has been unable to provide her name but she was undoubtedly affluent and shrewd. She proved in the eyes of the law that she and Joseph had been legally betrothed and brought an action against him for Breach of Promise.

Years passed in litigation which drained Joseph's purse and estranged his friends until eventually, deeply in debt and pursued by bailiffs, he and his family were forced to claim sanctuary in the church. They took up residency in the vestry, which apparently was enlarged for their convenience.

In this humble appendage to the church, Ann and Joseph spent the remainder of their married life with their nine children born between November 1684 and August 1698. Ann died in 1703 and Joseph on 16 December 1709, so it seems fitting that having lived and died there, an unobtrusive stone in the corner of the vestry at the end of the north aisle should mark Ann and Joseph's final resting place.

The living was mainly derived from the parish's lead mines, and with the discovery in 1717 of the rich lead bearing vein that runs along Edgeside to the north of Eyam, the living rocketed from a modest £150 to the incredible sum of £1,600 per year. Such an attractive stipend created competition for the pulpit amongst the titled gentry. First there was the Hon. Dr Edward Finch, fifth son of Sir Heage Finch, Earl of Nottingham, then the Hon.

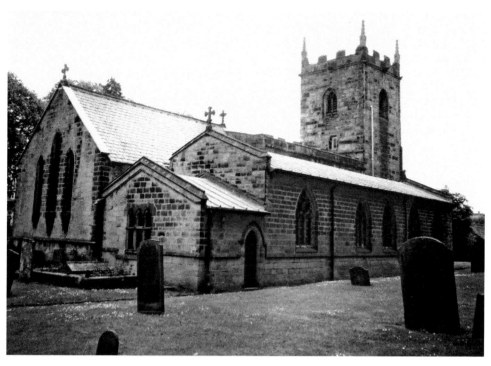

Eyam Church vestry was extended for the use of Reverend Hunt and his family.

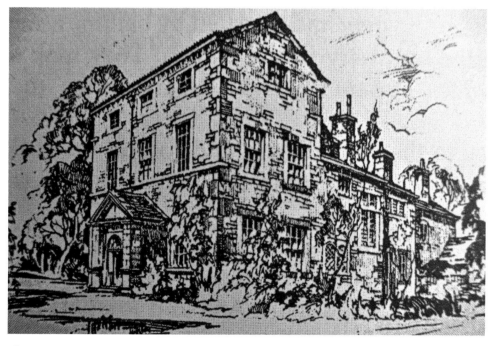

The vast Georgian rectory was built when the rich lead mines provided a lucrative living for the Eyam clergy.

Thomas Bruce, second son of the Earl of Kincardine. They were followed by the Revd Thomas Seward who was responsible for extending the rectory and building the vast Georgian addition.

It was the Revd Thomas Seward who on the last Sunday in August 1765, to mark the centenary of the outbreak of the plague, stood where Mompesson had stood in The Delph and preached a sermon as he had done. There was also a service to mark the bicentenary, and the service in its present form has been conducted every year since 1910. The day has become known as Plague Sunday.

His daughter Anna, who became a relatively successful poet, was born at the Vicarage in 1747, but the value of the living was shrinking gradually during this time. According to Anna Seward, writing in 1786, 'the value of Eyam living to my father, once near £700 per annum is not now more than £150'.

Revd Thomas Seward's successor, the Revd Charles Hargrave, became the new vicar of Eyam in 1790 thanks to the generosity of a worthy aunt who purchased the living for £2,000 from someone referred to rather mysteriously as the Duchess of C. Revd Charles Hargrave was a speculator who with several influential neighbours provided the capital for the first steam ship service to operate on the River Mersey at Liverpool. The first vessel to carry passengers was named the *Elizabeth* in honour of his daughter, but the venture did not prove financially successful. Sadly the rector was having even more financial problems according to this story taken from William Wood's book *Tales & Traditions of The High Peak.*

By this time, the rector and his wife had three young children and the upkeep of a ponderously rambling rectory. The lead mines had closed down, so the proceeds of the living were reduced to a comparative trifle. The aunt who had purchased the living and the mysterious Duchess of C had both died, when the rector received an order from her successor the Duke of B who had inherited the Duchess of C's estates. He was pressing for payment of the £2,000. The rector had never for one moment considered that the purchase money was unpaid, and although all his aunt's papers were strictly scrutinized, they could find no proof of the payment. The rector had no means of raising the money and although his family and friends were all sympathetic, they could not help financially, so the Duke commenced legal proceedings and a warrant was issued for the arrest of the Revd Charles Hargrave. Unable to pay, he would have been thrown into debtor's prison but each time the law hounds arrived in Eyam, the vicar was immediately taken to a secure hide-out where he stayed concealed until they had left. During the following five years, many attempts were made to arrest the rector but all failed thanks to the vigilance and devotedness of the villagers.

Eventually, two Bow Street runners named Digby and Brownlow were sent to Eyam. They had a 100 percent success rate when it came to apprehending debtors and criminals and they had a scheme which they considered would be foolproof. The plan was to enter Eyam at the dead of night and secrete themselves in the churchyard adjoining the rectory and arrest the rector at daybreak before any of his parishioners were able to alert him. Digby and Brownlow entered the village and made their way to the churchyard unseen. After stumbling over graves, they seated themselves under a stunted yew tree and for

a few minutes they sat in silence listening to the rustling of the leaves and the low moan of the wind in the swaying branches. It wasn't long before their surroundings began to imprint strange impressions on their minds. The two brave men were not feeling quite so brave when they noticed a figure, the semblance of a woman or ghost, coming towards them. Trembling with fear, they watched as she stopped around 10 yards from them and in a strange unearthly voice murmured 'Robert, come forth ... Come Robert. Come forth.'

Up sprang the terrified men, leaping and stumbling over graves. They left the churchyard and the village, watched by the demented old woman who was in the habit of wandering into the graveyard every night in the hope that she could call her long-deceased husband Robert back from his grave. What was written in Digby and Brownlow's report is not known but from them on, the rector was left to live in peace.

The Honourable Robert John Eden (1799–1870) became 3rd Baron Auckland in 1849. After an impressive education, in 1823, he was made deacon by the Bishop of Norwich, ordained priest by the Bishop of Worcester and appointed rector of Eyam. After only two years, he was transferred to other posts until nominated chaplain to King William IV in 1831. After William's death in 1837 he became chaplain to Queen Victoria for the next ten years when he became Bishop of Sodor and Man, then Bath and Wells until he resigned in 1869.

In 1960, a major remodelling of the rectory was carried out to bring it up to modern standards of comfort and convenience. The builders removed the derelict kitchen premises which had long been sealed off from the rest of the building, and knocked down the imposing three-storied Georgian wing, but the 1960s design incorporates the earlier proportion of the house which had been occupied by the plague heroes Stanley and Mompesson.

Local Industry

Mining, quarrying and farming were interrelated in the lives of the people as most lead miners kept farm animals and tended small fields in which they grew flax or oats. Flax is a food and fibre crop. The oil in its seeds is known as linseed, and when spun, the fibres known as linen are traditionally used for bed sheets, underclothes and table linen.

Did You Know
Grain would be ground in the village mill which stood on what is now known as Windmill Lane. There was an old tradition amongst millers called 'blooding the mill'. At midnight on St Martin's Eve (10 November) the miller would kill a cock and sprinkle its blood over the machinery in the belief that he would then be protected from accidents in the coming year.

The windmill was pulled down in 1875 and the stone was used to build the village school. The only evidence of its existence, apart from the name of the lane, is a 15" x 10" painting by John Plant made in September 1874 which now hangs in Eyam museum. Almost 100 years later, John Plant's painting was converted into the 1961 village well dressing. The painting clearly shows the windmill with an adjacent barn and cottage, and when the adjoining barn was converted into a house, the owner commenting that 'all the cracks and crannies were full of grain'. There's now an abandoned grinding stone on the site and if you look closely, you might just detect a circular patch that identifies where the windmill stood.

At the height of the eighteenth century, cotton spinning took over from flax and became an important village industry. The work was carried out in the homes of villagers at Lower Burch Place off the Causeway in the east, and Audrey Cottages at Little Edge in the west in an area known as Townhead. These were cottage industries, evidence of which is seen in the continuous range of mullion windows below the eaves at Audley Cottages to give maximum light for cotton spinning. The cotton-spinning industry was replaced by silk weaving in the early nineteenth century, a process that had originated from Macclesfield.

Did You Know
The Townhead building has a dovecot on the end wall. It is said that this was used to house carrier pigeons which in the era of the silk industry, took messages direct between Eyam and Macclesfield.

This industry may have made a gradual decline earlier if it hadn't been for an Eyam weaver named Ralph Wain. He could neither read nor write, yet he devoted all his leisure time to experimenting with various weaving principles until after many disappointments, in 1785 he discovered a revolutionary process whereby the designs and motifs could be reproduced on both sides of the material.

Did You Know
By the end of the eighteenth century, unable to cope with the mechanical processes and water power supplied by the rivers, Eyam's textile industries declined and were replaced by shoe factories.

In Slater's 1880s Directory shoe manufacturing is described as an important local industry in Eyam employing over 200 people. Even up to the 1950s, there were two large shoe factories in the village: Ridgeway Bros, later to become Edmund West, opposite the

The plaque on the former Townhead silk factory.

Boots and shoes like these on display in Castleton museum were worn by the villagers of Eyam.

Rectory, and Ridgeway Willis & Co., later G. Robinson & Co Ltd., at the Town Head. The first company made shoes entirely by sewing, but the later company used the then newer method of bonding the uppers to artificial soles, providing shoes mainly for Marks & Spencer and various catalogue companies. The last of the shoe factories closed down in 1979 due to foreign competition and cheap labour.

Lead Mining

Lead mining had been carried out in the area since Roman times and reached its peak in the mid-eighteenth century. It continued to prosper until the 1880s when the new Broken Hill deposits in Australia came into operation, and this signalled the beginning of the end. Derbyshire lead has very little silver content, and could not compete when Australian lead contained around 150 ounces of silver per ton. This made the silver content more valuable than the lead, which became more of a by-product that easily under-priced Derbyshire lead. However, it's ironic that during the prosperous times of lead mining in and around Eyam, the by-product of the lead had been piled in huge spoil heaps. Millions of tons of waste minerals, mainly barytes and fluorspar, took over from lead mining. Barytes was used for making paint. In 1895 the first shipment of fluorspar was sent to South Wales to the tin smelters, by 1904, fluorspar was being sent to the United States, and by 1922, the British steel industry took up the production.

In 1938, a small, complex processing plant based at Glebe Mine in the village upgraded the ore, producing 70 per cent of the country's high-grade fluorspar which was necessary for the war effort. The technique was further modified in the 1950s and today many of the plants in other countries have been modelled on the work done at Glebe Mine. In 1959 demand for fluorspar increased and as there was no room to develop further within the village, a new plant was built in the neighbouring village of Stoney Middleton and remains the largest high-grade fluorspar producer in the country. But the removal of Glebe Mines processing operations from the village and the demise of the shoe factory signalled the end of Eyam's industry, changing the character of the village back to its architype bucolic ideal where time has stood still.

In Conclusion

With coronavirus affecting households around the world, researchers have suggested that Eyam can offer us lessons on how to fight back. Sheena Cruickshank, professor in biomedical Sciences at the University of Manchester, said: 'Eyam is a snapshot of how one community was shaped by – and itself shaped – the spread of a disease.'

A study carried out by Dr Xavier Didelot and Dr Lilith Whittles, infectious disease modeller at Imperial College London, concluded that Eyam is important because it gives fantastic data for the plague, offering a unique opportunity to study how epidemics work. In larger populations like cities, details were slim, but Eyam records allow researchers to consider finer patterns at individual levels.

It is touching to think that the unimaginable sacrifice the villagers of Eyam made benefited not just those nearby communities but in the twenty-first century could still be benefiting the wider world.